IMAGES
of America

LA CAÑADA

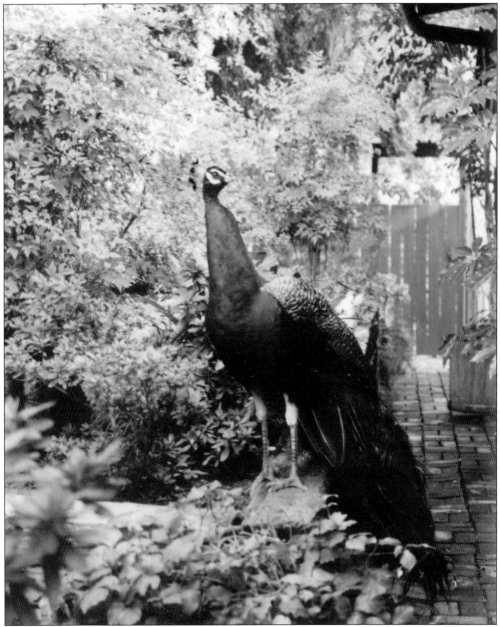

Nobody knows for sure how long the peacocks have been wreaking havoc in La Cañada neighborhoods. These beautiful creatures have been both loved and hated. One story tells that Lucky Baldwin gave a pair to some La Cañada residents. Another version is that Frank Doherty imported them because he heard that they ate rattlesnakes, which seemed more troublesome at the time. Yet another story has it that the peacocks were escapees from Victor McLaglen's backyard zoo.

ON THE COVER: The Dunham family lived in the Alta Canyada foothills in the early 1900s. Their driveway became Palm Drive. (Courtesy of Don Birchall.)

IMAGES

of America

LA CAÑADA

Yana Ungermann-Marshall

ARCADIA
PUBLISHING

Published by Arcadia Publishing
Charleston SC, Chicago IL, Portsmouth NH, San Francisco CA

Printed in the United States of America

Library of Congress Catalog Card Number: 2005937813

For all general information contact Arcadia Publishing at:
Telephone 843-853-2070
Fax 843-853-0044
E-mail sales@arcadiapublishing.com
For customer service and orders:
Toll-Free 1-888-313-2665

Visit us on the Internet at www.arcadiapublishing.com

This book is dedicated to all of those who have lived on the land that is now named La Cañada Flintridge and in memory of all of their stories still to be told. It is also dedicated to the wonderful Ungermann and Pizzo families and to my husband, Michael Marshall, and my mother, Mary Ungermann, who support me in my secret adventures and scavenger hunts, patiently, as I burn their dinners and forget their appointments.

CONTENTS

ACKNOWLEDGMENTS

This book is composed of images from several public and private collections. Without these images, this book would have only been a rehash of earlier accounts of La Cañada's history. Through George Ellison's expert knowledge of the Glendale Public Library's Special Collections room, I was provided with volumes of images in this book; Don Graf, retired information supervisor and resident caretaker at Descanso Gardens for many years, provided much knowledge; and David Brown, present director of Descanso gardens provided access to the Boddy Archives. Doug Caister, supervisor at La Cañada Irrigation District and La Cañada resident, whose family lived on Angles Crest when it was still Orange Groves, spent hours with me, recalling old businesses, families, and street names. Virginia Robertson, longtime resident of La Cañada since her childhood in the 1930s and a retired employee of the La Cañada Post Office, lives in her historic La Cañada home, with many of the furnishings as they were in the 1930s. Melissa Patton, and Tim Gregory, of the Lanterman Historical Museum Foundation at The Lanterman House, patiently and expertly shared their knowledge and helped me find and identify many people and places. Don Birchall, a longtime La Cañada resident who collects memorabilia and photographs, supplied the cover photograph and other images for this book. The La Cañada Flintridge Public Library provided access to the files from the old La Cañada Historical Society, and their assistance was very helpful. Cliff Kirst provided me with his wonderful and very well cared for family albums, many good stories, and much valuable information, which only a good memory can provide. This book would have no life without the memories and contributions of these people. And thank you, Mom, for doing all the typing on the long reports I wrote when I was little.

INTRODUCTION

There are many versions of La Cañada's history. Each version can make La Cañada seem like a different place . . . and perhaps it was.

This version of La Cañada's history attempts to show a wide-angle view of a variety of perspectives of the area, as it evolved from settlements of people, who may have lived 12,000 or more years ago and left few subtle footprints, to the well-documented Spanish land grants, and to more recent settlers of the land as it became a suburb of Los Angeles in the early 1900s. These photographs represent only a very few of the myriad interwoven family lives and perspectives of what was La Cañada. There are many stories left untold and many still to discover and tell.

La Cañada was the name given to the northeastern valley of a large Spanish land grant known as Rancho San Rafael, or La Zanja (water ditch). In 1784, the rancho was given to Don Jose Maria Verdugo, who had asked the governor of California for the piece of land to raise cattle after his retirement from serving the King of Spain. Verdugo had been stationed at both the San Diego and San Gabriel missions and as the Tongva (the previous occupants), who had been gathered to work at the missions, retreated to the mountains or succumbed to diseases brought by the new settlers, the land appeared to Verdugo to be his for the taking. "La Cañada" was coined as a descriptive phrase for "the mountain valley" or "the canyon" by Ignacio Coronel, who, to the Verdugo family's dismay, was granted this portion of Verdugo's large estate in 1843. Coronel's section of land was not a small canyon. What Coronel described as "La Cañada" spanned approximately 7–15 miles (depending on the source), from the northern part of the Arroyo Seco on the east, to the approximate border of what is now Tujunga on the west.

Before Verdugo arrived, the land was home to a great cultural group who spoke a language in the Takic family of Uto-Aztecan linguistic origin, known as the Tongva. They populated the approximate area of Los Angeles County, and this included Santa Catalina Island. The Hahamongna lands were populated by a subgroup of Tongva, who lived and traveled along the seasonal creeks and streams of what are now places named Altadena, Linda Vista, Glendale, Eagle Rock, the Arroyo Seco, Angeles National Forest, La Crescenta, and La Cañada Flintridge. All of the Tongva people of the San Gabriel vicinity were later named "Gabrielino," as they were taken to the San Gabriel Mission.

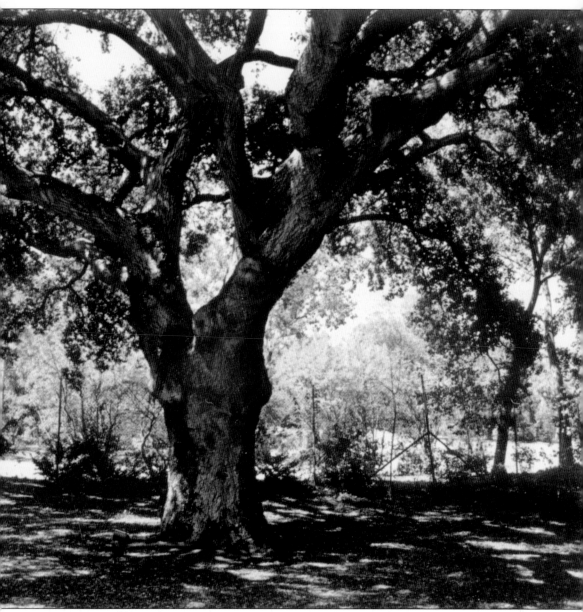

There are still a few of the very old coast live oak trees in La Cañada that were alive before European colonization began to take place in the local area. Photographed during the 1950s, this oak in the Rosarium at Descanso Gardens has seen it all come and go. It is estimated to be at least 350 years old, but could be much older. An earlier photograph from the year 1907 shows this tree's huge stature in relation to other surrounding oaks at that time.

One

ADAPTERS AND IMPOSERS
SQUATTERS, SETTLERS, BANDITOS, LANDOWNERS, AND THE REST

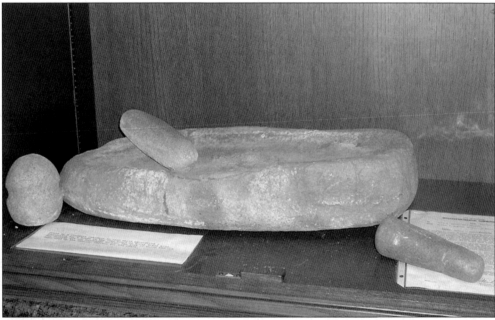

The first people to live in the area that was called La Cañada from 1843 to 1976 used grinding tools such as these, found in Glendale, to grind roots and seeds for food, medicine, pigments, and adhesives. Because grinding tools have been found along many old watercourses around La Cañada and maps drawn in the early 1800s indicate tribal campsites around those areas, it is believed that these people were adaptable to life along the streams flowing down from the mountains and canyons of the San Gabriel, Verdugo, and San Rafael. The people last remembered to live in the La Cañada area around the Arroyo Seco before the missions were built were known to the early Californios (settlers from Mexico) as Hahamongna (people of the fruitful valley and land of flowing waters), or Hahamongvit. Historian W. W. Robinson wrote of grass huts along the Arroyo, but referred to the camp as Haleameupet. Perhaps these differing names still referred to the same people spoken in the dialects of nearby clans, or there were several clans who shared this area. What was once Oak Grove Park, and used as a campground for local La Cañadans in the 1920s through the 1980s, was later renamed Hahamongna Watershed Park in remembrance of these people. (Courtesy of Glendale Public Library, Special Collections.)

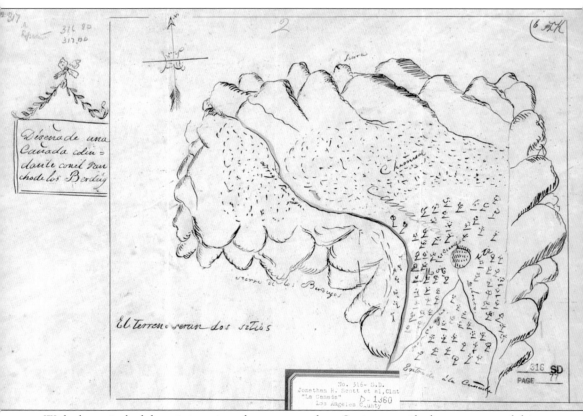

With the arrival of the missionaries, who were sent from Spain to pacify the occupants of this land by converting their religious faith to Catholicism, came the soldiers to claim the land for Spain. Those people who did not go to the missions to live and work willingly were gathered up from their hiding places in the mountains and canyons by the soldiers. Later portions of this newly uninhabited land were granted as favors to officials of the army, who had traveled through these lands on their journeys from mission to mission. This is a map of the *diseno* of La Cañada, probably drawn in the early 1800s for the Verdugo family. The Verdugo family was first granted a large expanse of land that was bordered by the Arroyo Seco on the west, Tujunga on the east, and the San Gabriels to the north. The Verdugo land went to the southern tip of Glendale on the south, but they later lost the northern valley, La Cañada, to Ignacio Coronel, and although they regained the land, it was later lost to Alfred B. Chapman. (Courtesy of California State Library Picture Catalog.)

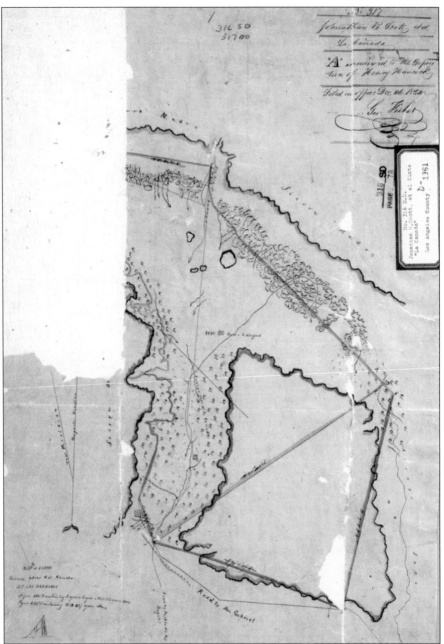

The *diseno* of La Cañada was granted on May 12, 1843, to Ignacio Coronel, a member of the *ayuntamento* (city council) of Los Angeles and a schoolteacher at the presidio on Olvera Street when California was under Mexican rule. Coronel named the property La Cañada Atras de Rancho Los Verdugos (the glen behind the Verdugo Ranch). Ignacio Coronel sold Rancho La Cañada in 1852 to Jonathan Scott and Benjamin Hays, law partners in Los Angeles (California Land Case No. 317). Scott and Hayes petitioned for U.S. recognition of the Mexican title to Rancho La Cañada. This took 14 years (some during the Civil War). While the petition was up for review, Hayes sold his share to Scott, and Julio Verdugo traded part of Burbank to Scott in exchange for La Cañada. (Courtesy of California State Library Picture Catalog.)

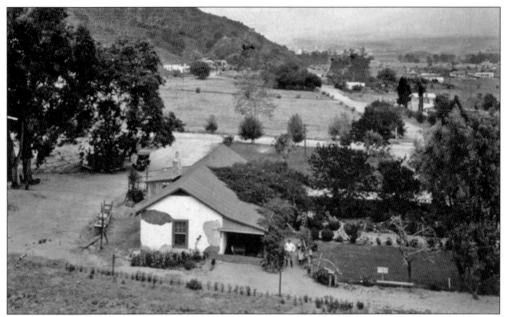

After Julio Verdugo's rancho was ruined by floods, he sold La Cañada to Alfred B. Chapman (a Glendale landowner), who was Jonathan Scott's son-in-law. In 1872, Chapman and his law partner were awarded La Cañada. The Catalina Verdugo Rancho (once part of the Verdugo Rancho in Glendale's Verdugo Canyon) is pictured above. (Courtesy of Glendale Public Library, Special Collections.)

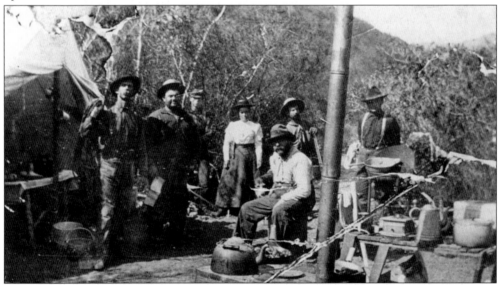

The early settlers were tough and resilient. As canyon dwellers, they often lived in temporary camps, prepared to pack up when necessary. Many people came from Los Angeles just to enjoy the fresh air and scenery. It is possible that the people in this photograph are looking for a nice spot to settle, or maybe they heard about a mine on a small hill somewhere around the present border of Hospital Hill and Descanso Gardens. The settlers who came to the valley to stay found ways to make a living by carrying water to the ranchers in the lowlands, or by selling firewood. And yes, some even mined the hills. (Courtesy of California State Library Picture Catalog.)

Col. Theodore Pickens came from Kentucky in 1871 and settled in the hills above La Cañada and La Crescenta. He acquired the water rights to the canyon. This water source in Pickens Canyon was one of the mos· valuable for La Cañada, and many early settlers fought for it, or otherwise had to deal with Pickens to get a reliable supply of water. At first, the water was carried in large tanks or barrels by horse or mule cart. Later redwood flumes were installed to carry water to the valley below. (Courtesy of Virginia Robertson.)

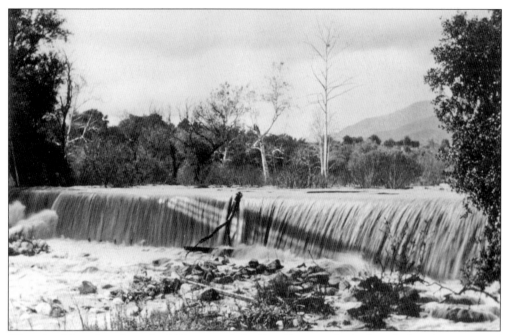

When health seekers from the Midwest and the East Coast—who had read advertisements and magazine articles about the dry and healthful climate of the area—came to the La Cañada Valley in the early 1800s, many were not prepared for the heavy rains. The water often rushed down the canyons to flood the valley below. (Courtesy of Don Birchall.)

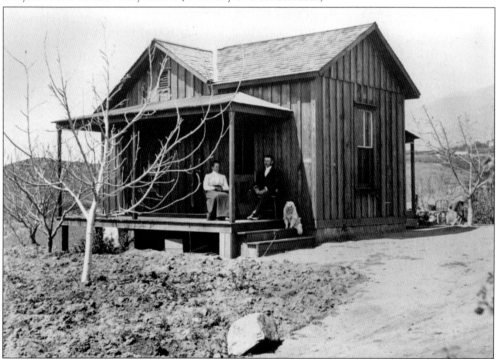

Many of the first settlers' homes were washed downhill during rainstorms. It was not uncommon to move or rebuild a home in those early years. (Courtesy of Don Birchall.)

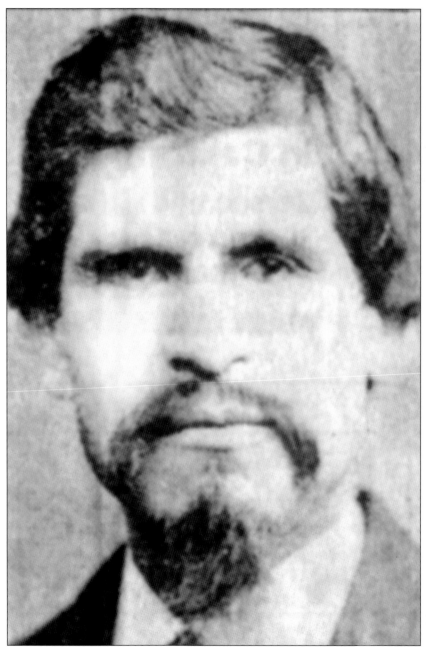

The bandito Tiburcio Vasquez was one of the last desperadoes of California's era of outlaws. He pillaged what is now northern Los Angeles County from 1853 to 1875. Vasquez eluded capture longer than any other of the Californio banditos. He had a reputation similar to that of Joaquin Murrieta, or Zorro. As the Californios were displaced by the Americans (the newer settlers who were coming from the East Coast and the Midwest), Vasquez, who lost his family land in Monterey County, made it his mission to take revenge upon the invaders. Also known as a "gentleman bandit," he was a hero to many Californios, as he was said to be involved in very few actual killings, and only when necessary. So goes the legend. . . . (Courtesy of Glendale Public Library, Special Collections.)

15

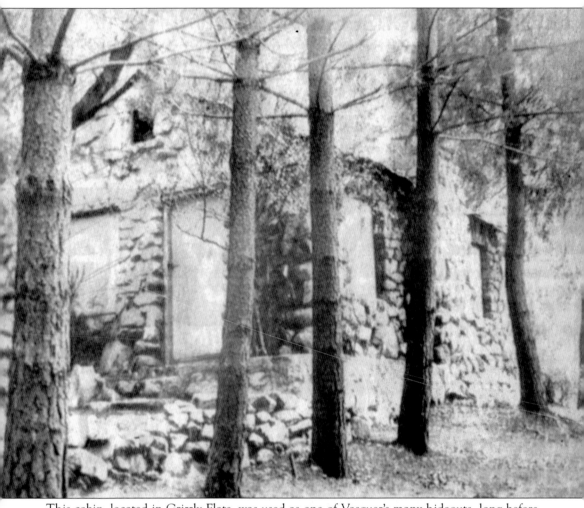

This cabin, located in Grizzly Flats, was used as one of Vasquez's many hideouts, long before the Chilao Campgrounds were created for weekend campers 25 miles above La Cañada on the narrow and torturous trails, which were eventually used to gain access for the builders of the Angeles Crest Highway. After raiding the lowlands, Vasquez would take refuge in the hills. What is now Vasquez Rocks is said to have been one of his favorite hideouts. His other hiding spots were near the old Soledad Road that once crossed La Cañada diagonally through the valley floor and into the mouth of a canyon, which led into the San Gabriel Mountains. After a raid, he often used Dunsmore Canyon above La Crescenta as a getaway. It led to two separate routes, which offered easy access to a myriad of secret trails crossing the Angeles National Forest. Both routes also led to Tujunga Canyon and the Arroyo Seco. (Courtesy of Glendale Public Library, Special Collections.)

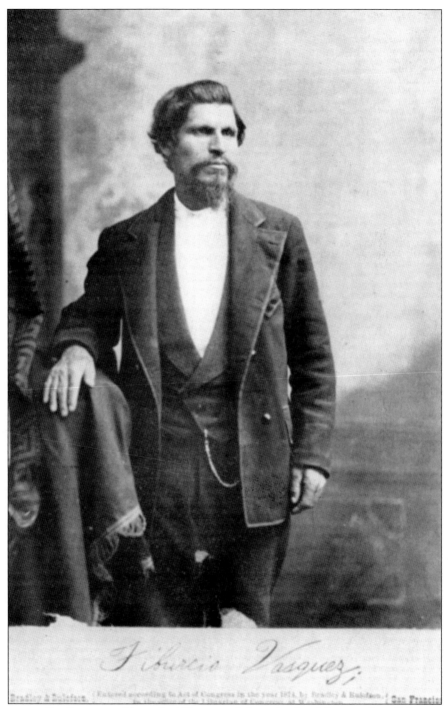

Vasquez was finally captured by a sheriff's posse while eating breakfast at a friend's house in Los Angeles. Vasquez submitted to having his photograph taken with the hope that sales of the pose would help pay for his court defense costs. But it was too late. He was brought back to San Jose, where he was tried for other crimes in Northern California and quickly hanged on May 15, 1875. (Courtesy of Glendale Public Library, Special Collections.)

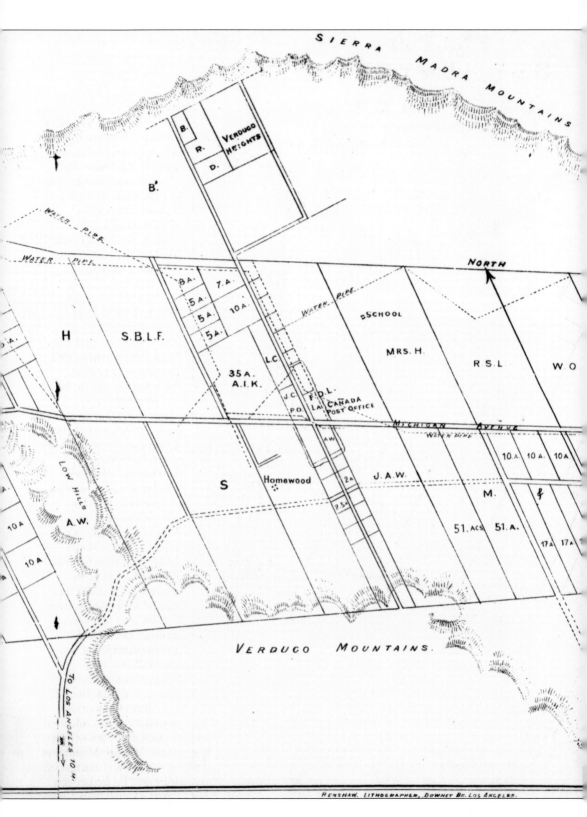

SIERRA MADRA MOUNTAINS

B.
R.
D.
Verdugo Heights

B'.

WATER PIPE

WATER PIPE

NORTH

H

S.B.L.F.

8 A.
7 A.
5 A.
5 A.
10 A.
5 A.

WATER PIPE

□ School

MRS. H.

R.S.L.

W.O

35 A.
A.I.K.

L.C

J.C

F.D.L.
La. Canada
Post Office

P.O.

MICHIGAN AVENUE

WATER PIPE

10 A. 10 A. 10 A.

A.W

S

Homewood

A.W.

2 A.

J.A.W.

M.

&

2.5 A.

51. Acs 51. A.

17 A 17 A

Low Hills
A.W.

10 A

10 A

VERDUGO MOUNTAINS.

TO LOS ANGELES 10 M.

RENSHAW. LITHOGRAPHER, DOWNEY BR. LOS ANGELES.

18

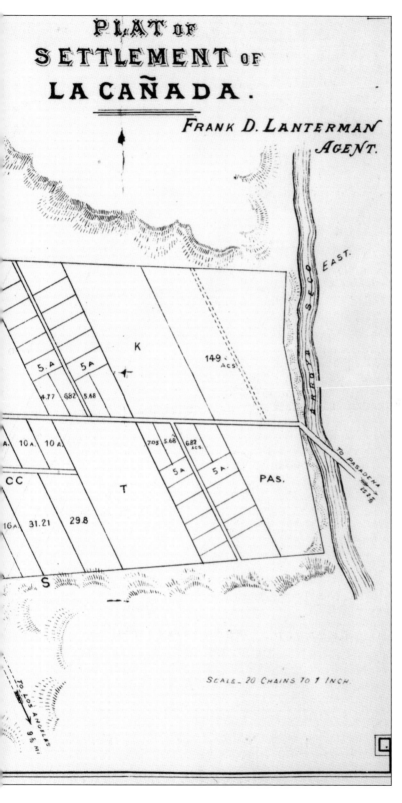

PLAT OF
SETTLEMENT OF
LA CAÑADA.

FRANK D. LANTERMAN
AGENT.

K

5 A 5 A 149 ACS

4.77 6.82 5.68

A. 10 A 10 A 7.05 5.68 6.82 ACS

CC T 5 A 5 A PAS.

16 A 31.21 29.8

S

ARROYO SECO EAST.

TO PASADENA 15.28

TO LOS ANGELES 9½ MI.

SCALE - 20 CHAINS TO 1 INCH

After the floods and Julio Verdugo's loss, there was a long period of drought. In 1872, Chapman and Glassell were awarded part of Rancho La Cañada. In turn, Glassell and Chapman sold it to Col. A. W. Williams and Dr. Jacob C. Lanterman, who were both health seekers from Lansing, Michigan. Lanterman was in the process of suing Williams, who died before the land was subdivided for resale and development in 1881. However, as seen in the earlier photographs, there were other settlers in the valley. Part of the foothills and canyons were taken by Pickens, Hall, Dunks, and others who lived near and controlled the water sources for the valley below. In Frank D. Lanterman's plat, the Sierra Madre Mountains (San Gabriels) are north. The main street through town was named Michigan Avenue (which later became Foothill Boulevard) in remembrance of the Williams' and Lantermans' northern home. Note that the plat shows the southern boundary of La Cañada to be well into the foothills of the Verdugo Mountains at that time. (Courtesy of Glendale Public Library, Special Collections.)

19

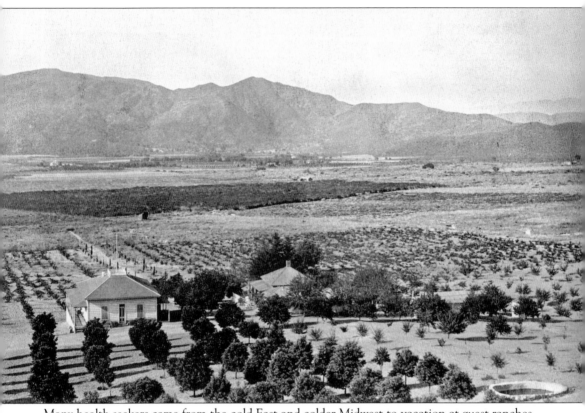

Many health seekers came from the cold East and colder Midwest to vacation at guest ranches, such as this one, and enjoy the warm sun and dry air. Some later bought acreage in the La Cañada Valley. This may be a photograph of the Dunks Mountain Retreat at Verdugo Heights. This particular area, around the top of Haskell where old School Road ended, is also where the estate of Frank P. Doherty stood. Doherty was a well-esteemed Los Angeles lawyer and is still remembered in the area today. To the children of the 1940s and 1950s, he is more remembered for the long, dark driveway lined with cypresses, which led to his house, and the special treats he gave out on Halloween. During the time that the Dohertys lived there, they had an agreement with the Kirst family for free water rights. The Kirst family owned the rights to the water, which came through the tunnel at the canyon above School Road. The palatial Doherty house was later torn down, and the property was developed by Phil Kirst and, later, an outside developer named Shapiro. Nearby were the properties of Will D. Gould, also a Los Angeles attorney, who kept a summer resort called Highland Park, where Angeles Crest now enters the mountains below the Gould Canyon Bridge. Other settlers of the high slopes at the immediate foothills of the San Gabriels were Col. T. S. Hall, S. Hillard, A. I. Ketchum (a health seeker from Boston), and Chester Williams. One of the houses pictured may belonged to Uncle Dave, who lived between the Dohertys and the houses on the old School Road. His address was Uncle Dave, La Cañada, California. All of the rooms in his house could only be entered from the outside; there were no internal doorways. His full name was David Hitchcock, Alfred Hitchcock's brother. Dave liked to hang out at the Hollywood Roosevelt. (Courtesy of Glendale Public Library, Special Collections.)

For many years, the Dunham family home was among the largest in La Cañada. Stella Lanterman sold this piece of land, given to her as a wedding present, to Ed Dunham, who managed the Pico House Hotel in Los Angeles. The house burned down in 1932. Many of the early settlers of the valley were not prepared to survive the hurricane-strength winds, which often swept down through the canyons and caused fires. Because of flying cinders from the fires in the wood stoves and the candles and oil lamps used for light, fires were much more prevalent when the settlers came. (Courtesy of Don Birchall.)

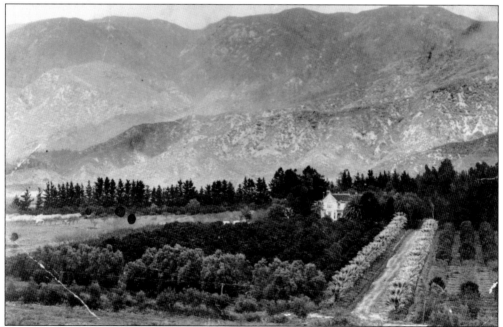

This is a view of the Dunham house from Brown Hill, now the site of the YMCA on Foothill Boulevard. The young palms that lined the driveway to the house were planted in 1895 by the Barnums, the Dunham's neighbors. (Courtesy of Glendale Public Library, Special Collections.)

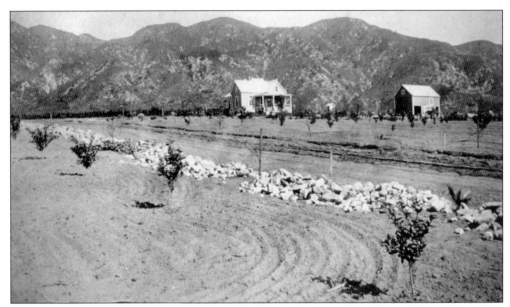

This is the Barnum house. Cortez and Alice Barnum were among the earliest settlers of the valley, and they lived at the top of Alta Canyada. They learned how to farm during the dry periods and how to survive the rainy seasons when the valley was flooded. But not all early settlers stayed. The Barnums moved back East after a long drought period. When their son Starr Barnum got old enough, he moved back to La Cañada and lived near La Cañada School on Fairview. (Courtesy of Glendale Public Library, Special Collections.)

In 1890, Ralph G. Moses moved to La Cañada with his mother and built this house near Michigan Avenue, on what later became Palm Drive. It was a two-room house with a lean-to kitchen. Ralph was one of the health seekers who moved to La Cañada for the air quality. He had damaged his lungs while working with photography chemicals in San Francisco. Five consecutive generations of the Moses family lived in this house, which stood in a large naval orange orchard in the early years. (Courtesy of Virginia Robertson.)

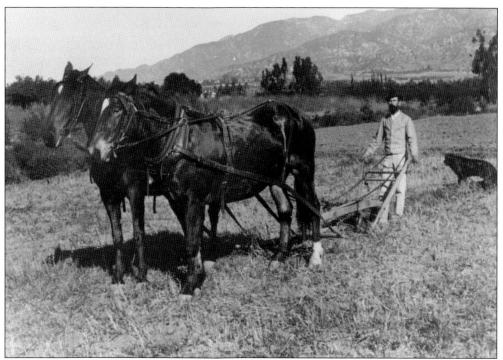

Ralph Moses and his mule teams did field tilling for farms and acreage in much of the valley. (Courtesy of Don Birchall.)

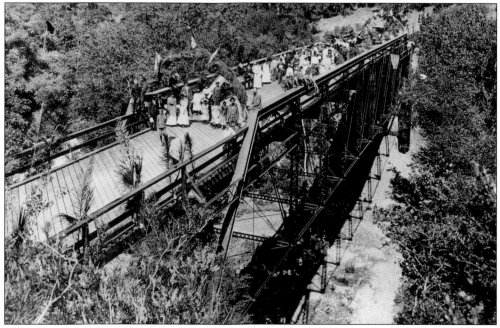

Native plants, such as yucca and palm fronds, were used to decorate the Devil's Gate Bridge at its 1893 dedication. Before the bridge was built, it was very difficult to travel to and from Pasadena across the Arroyo Seco during a rain. (Courtesy of Glendale Public Library, Special Collections.)

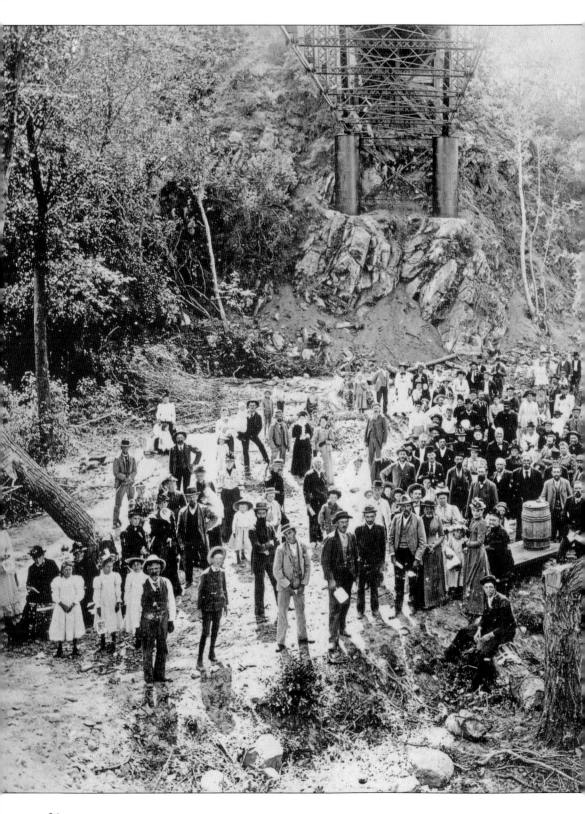

In this 1893 dedication party photograph of Devil's Gate Bridge, the following are present but difficult to locate in the small image: Amoretta Lanterman; Starr Barnum, in his mother's arms; and Charles Pate, an Englishman who drove a Model T and was one of the few photographers in La Cañada. Some of the photographs in this book were taken by Pate. He also played the guitar. (Courtesy of Glendale Public Library, Special Collections.)

Several canyons were filled with dirt and rubble to make the future roadbed of Foothill Boulevard. Horse-drawn wagons were used to drop the dirt and rubble through openings made in the bridges until the canyons were filled. This canyon was at El Camino Corto and Hillard. The stone arch was once part of a water drainage tunnel (or culvert). Culverts, such as the one below the bridge, were built years earlier and once carried water from the hillsides into the valley, providing water for homes and crops. During the dry seasons, men dug into the hillsides, blasting away the granite in order to tap water. Some water was hauled away by small railroad cars to be sold. Some of the holes drilled at the beginning of the 1900s are still producing water. (Courtesy of Glendale Public Library, Special Collections.)

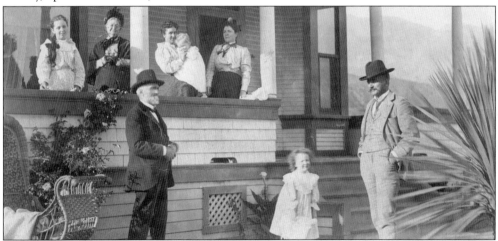

Jacob and Amoretta Lanterman's son Frank Sr. built his home on Orange Knoll Avenue (c. 1895). Three generations of Lantermans are shown in this photograph of the Orange Knoll house, which was torn down in 1948. Not all of the people have been identified, but Frank and his second wife, Mary, holding the baby, are pictured. Other pictured here, from left to right, are (first row) Jacob Lanterman, one of Frank and Mary's daughters, Frank Sr.; (second row) unidentified, Amoretta Lanterman, Mary and baby, and unidentified.

This rose-covered cottage seems to have had no lack of water. La Cañada development brochures tell of the water line that the Lantermans "arranged for" with Pickens and his water source in Pickens Canyon. A more colorful version of the story states that Amoretta Lanterman, fed up with the lack of water one dry year, took a shotgun and went up the mountain to give Mr. Pickens a visit. She is said to have come back to Homewood with a "water deal." (Courtesy of Don Birchall.)

Settlers from the East Coast and Midwest were now able to put in their lawns and import some of their other garden favorites from back home. (Courtesy of Don Birchall.)

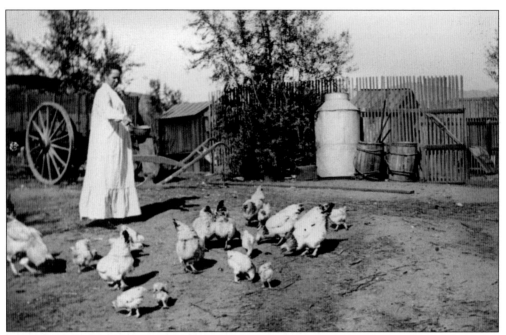

Settlers that had come to La Cañada earlier were already adapted to the "California lifestyle." This woman is feeding her flock of light Brahma chickens in her nightgown, as so many Southern Californians did. Along the fence in her backyard is a wagon with a hitch, a plow, an outhouse, a large container, and rain barrels for collecting water. (Courtesy of Don Birchall.)

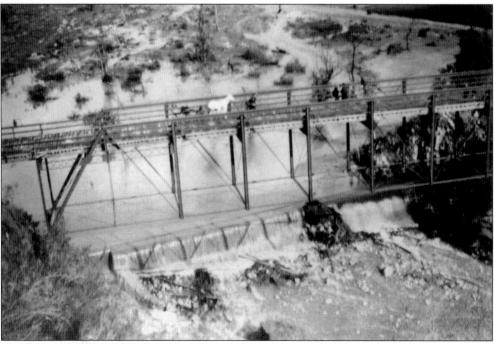

Devil's Gate Bridge made it possible to get to and from Pasadena during this flood in November 1900. In 1920, the County of Los Angeles built its first water conservation and flood control dam, Devil's Gate Dam. (Courtesy of Glendale Public Library, Special Collections.)

In 1904, after Pauline and Nicholas Kirst traded their hotel in Los Angeles for the 90-acre Ketchum Ranch in La Cañada, they moved into the Ketchum house, located where the end of Daleridge is now, above Baptiste Way. From their home, they had a view of Devil's Gate and the Arroyo Seco. (Courtesy of the Kirst collection.)

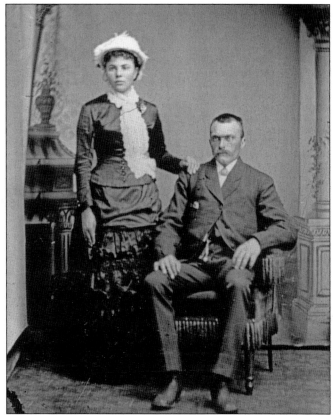

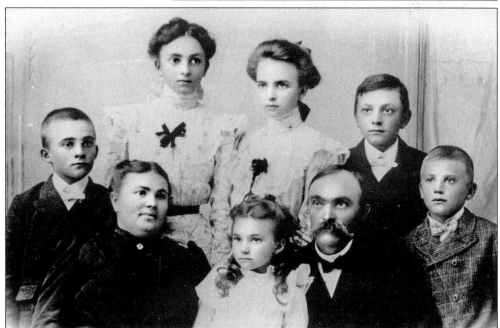

Pictured here with their parents, Nicholas and Pauline, are the Kirst children—Mary, Frances, Burt, John, Albert, and Barbara. (Courtesy of the Kirst collection.)

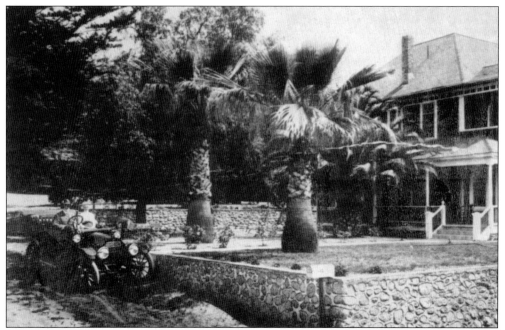

Mr. and Mrs. Jesse Knight (for whom Knight Way was named) lived on the corner of Olive Lane and Angeles Crest Highway. In this c. 1912 photograph, the Knights are sitting in their car, parked in front of the family home. The Knights owned a packing plant and a large orange grove near the house. (Courtesy of the Kirst collection.)

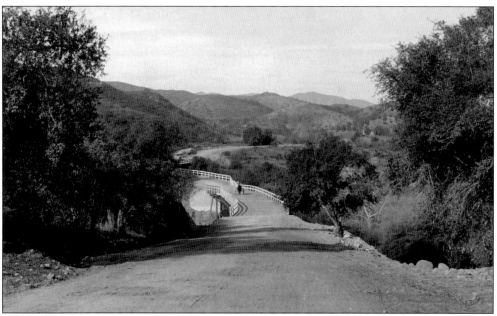

This is what the road to La Cañada from Pasadena looked like in 1913. In this photograph, a lone horse and buggy is traveling over the Devil's Gate Bridge to Pasadena, probably for supplies or to make a delivery. (Courtesy of Glendale Public Library, Special Collections.)

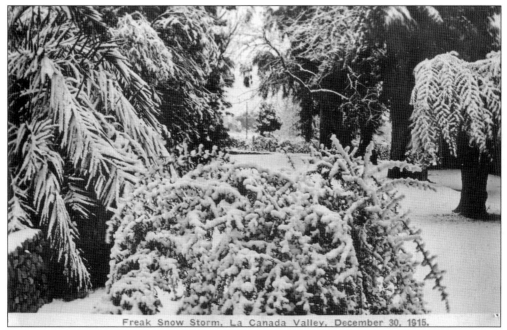

Freak Snow Storm, La Canada Valley, December 30, 1915.

Snowfalls were very rare in La Cañada Valley, even though most of La Cañada's water came from snow melting in the mountains. On December 30, 1915, it snowed all the way down into the valley, and whoever had a camera went outside to photograph the unusual sight of snow on their palm trees. (Courtesy of Glendale Public Library, Special Collections.)

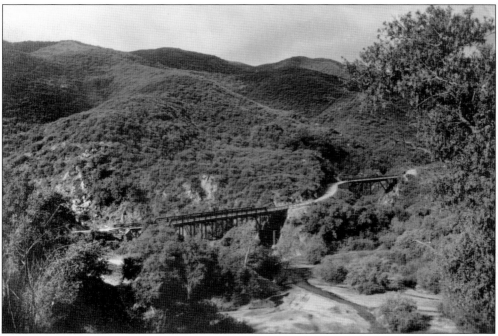

La Cañada's first mailman, Frank Vernon Hall, drove the very first Model T to be used in the California mail service to Pasadena on this unpaved buggy path every morning to get the mail. (Courtesy of Glendale Public Library, Special Collections.)

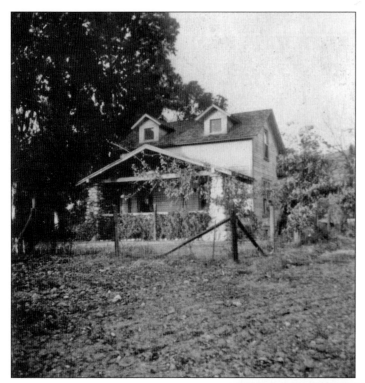

This was Nicholas and Pauline Kirst's first ranch house. From 1916 to 1924, their son Burt and his wife, Gertrude, lived in this house. In 1924, Burt and Gertrude bought 50 acres from Will D. Gould and built a house on the corner of Gould and Michigan Avenues. (Courtesy of the Kirst collection.)

Nicholas Kirst died in an accident about three years after the Kirsts moved to La Cañada. One of his horses stumbled while Nicholas was in the stall with him, crushing his ribs. Burt and Albert, two of his sons, helped their mother, Pauline, with the vineyards after his death. (Courtesy of the Kirst collection.)

Burt Jr. and his cousin June, who was visiting from Los Angeles, are sitting on the steps at Burt (senior) and Gertrude's ranch house in 1917. (Courtesy of the Kirst collection.)

This was a very heavy snow for La Cañada. Albert Kirst's family house is pictured here in 1931. It stood on Foothill Boulevard, facing Gould Avenue, until the 1950s when the Foothill Freeway was put in. (Courtesy of the Kirst collection.)

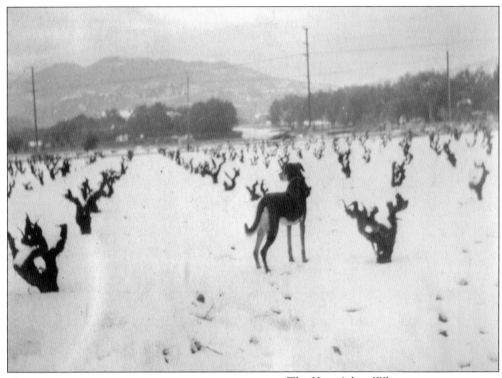

The Kirsts' dog, Whoopee, seems bewildered by the unusual site of snow in the vineyard in 1931, but maybe he just wonders where all of the rabbits are hiding. Whoopee never walked anywhere. He always ran. This included running across Mrs. Knight's fishpond on the way to the tomato fields at the north end of the ranch. (Courtesy of the Kirst collection.)

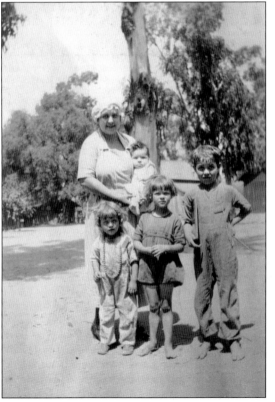

Phil, in his mother Gertrude Kirst's arms, is pictured here with Buddy Jr., Betty, and Bob in front of the barn. (Courtesy of the Kirst collection.)

John Kirst and his wife, Louise, are fooling around with Burt and Gertrude Kirst and Bill Lyons (also of La Cañada) in this photograph. Together, John and Burt cleared the brush and trees off about 100 acres to grow tomatoes. This area was located below Haskell, later the Angeles Crest Highway, and Louis Pizzo's property. They also built Vineta Street on the southern end of their property. John Kirst later went into the construction business and worked on many large projects in Southern California with his sons Jim and Frank. (Courtesy of the Kirst collection.)

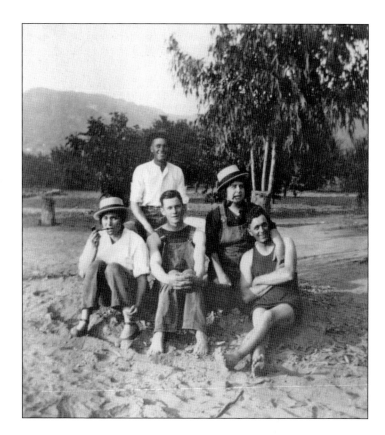

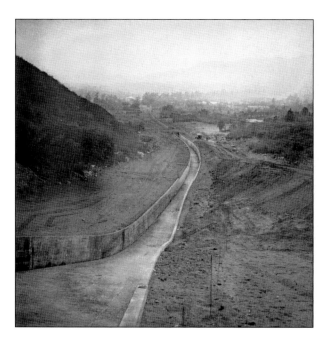

By looking at this photograph of the Pickens Canyon Wash, newly built in 1935, it is difficult to imagine that it once was filled with over 10,000 trout. The wash, at the border between La Cañada and La Crescenta, was first planted with fish in the early 1880s, when it was still a stream. Will D. Gould was able to convince the state to plant the fish, which flourished and grew to be very large. However, a huge forest fire in 1896 killed all of the trout in both Pickens Canyon and the Arroyo Seco. (Courtesy of Glendale Public Library, Special Collections.)

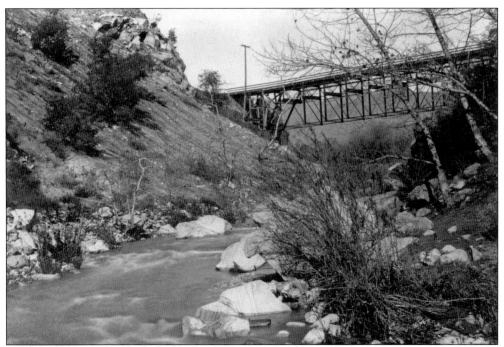

Not all of the canyons were filled with rubble for roads, nor were all steams lined with concrete. Some bridges still remained over canyons to allow the water from the mountains to flow its natural course. (Courtesy of Glendale Public Library, Special Collections.)

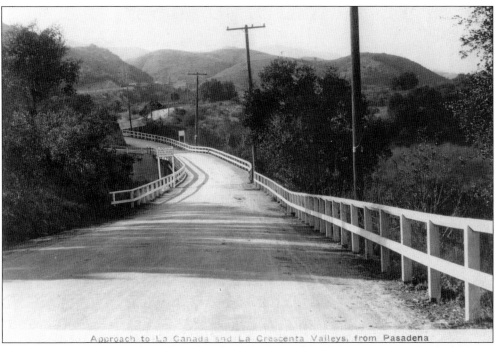

Approach to La Canada and La Crescenta Valleys, from Pasadena

The road between La Cañada and Pasadena had not changed much by 1938, except for the addition of telephone lines. (Courtesy of Glendale Public Library, Special Collections.)

This is the Valley Water Company, who provided the eastern side of La Cañada with ground water from a well, in 1940. The western side of La Cañada's water, which had been controlled by the Lantermans, later became the La Cañada Irrigation District. Both water companies began to import water from central California. (Courtesy of La Cañada Irrigation District.)

In 1945, Kirst's new development was built west from the vineyards toward the Arroyo Seco. This was the first housing development in Southern California after the war. (Courtesy of the Kirst collection.)

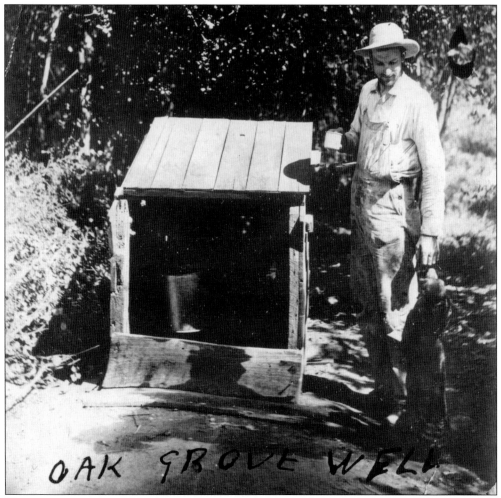

This is an opening to a ground well in what was, at the time of this photograph, Oak Grove Park, on the west bank of the Arroyo Seco (La Cañada's eastern boundary). This well was operated by Valley Water. It is now in Hahamongna Watershed Park. (Courtesy of Glendale Public Library, Special Collections.)

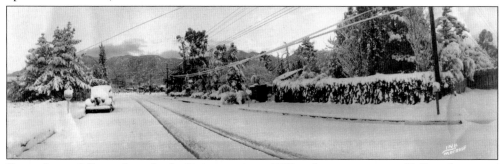

So much was different from the freak snowstorm in 1915 to this snowstorm in 1949, with most of the changes occurring during the 1930s and 1940s. The sky is now filled with power lines. The car on the left is parked on the corner of Castle Road and Lyans Drive. (Courtesy of La Cañada Irrigation, W. H. Ink Collections.)

By 1950, most roads had been paved and some had two lanes with white lines painted down the centers. There was still no need for a signal or stop sign at this fork in the road, however. (Courtesy of Glendale Public Library, Special Collections.)

Louis Pizzo married Vicenzina Castellano in Florida and brought her to California in the early 1900s. They raised six children in Pasadena while Louis operated his dairy and vineyards. He also helped with local building and construction projects, which included hauling boulders with his mule team to build the Rose Bowl. When the family home on Wyoming Street was lost to eminent domain for John Muir High School in Pasadena, Louis bought a parcel in La Cañada, which he later subdivided and gave to his children. (Courtesy of Pizzo family.)

Bill McGrath (center) grew up in La Cañada with his sister and two brothers at 4330 Oakwood Avenue. His father was a street and highway contractor. He later married Lil Pizzo and moved to Pizzo Ranch Road after it was subdivided in 1950. Pictured in front of Bill's new 1950s ranch-style house, from left to right, are Albert and Sandy Pizzo, with Patti in her arms; Louis Jr., who later married Pat, built a house on the lot next door to this house, and had three children—Louis III, Lori, and Linda; Louis and Vicenzina Pizzo; Bill McGrath, holding Michelle; Lil McGrath (right), with daughter Sherri McGrath; Mary Ungermann, with daughter Susy (who lived at the top of the road); Peggy Pizzo, who built a house on the corner lot; and Yvonne Pizzo. Albert and Sandy later divorced. Sandy married a nephew of George Patton's and moved to Lake Vineyard in Pasadena. Albert remarried and has a large family in Newport Beach. (Courtesy of the Pizzo family.)

The Ungermanns' California ranch-style house was built in 1950. Parked in front, at the top of the driveway, are Susy, her dad's 1953 MG, and her mother's Kaiser Manhattan. Susy had many pets, including a donkey, rabbits, guinea pigs, hamsters, rats, snakes, lizards, toads, fish, ducks, dogs, and cats. The canyon was on the side of the house for easy hiking access, and Angeles Crest Highway was close by for trips in the MG to Switzer's Camp. The neighbor kids played games on the dead end street and crawled around in the tall grass in the empty fields before they were tilled for summer. (Courtesy of the Pizzo family.)

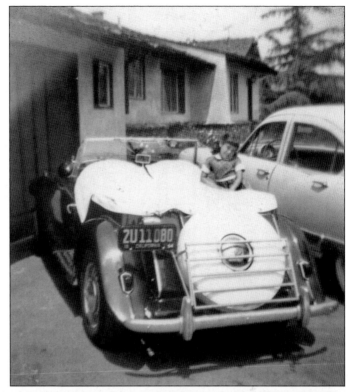

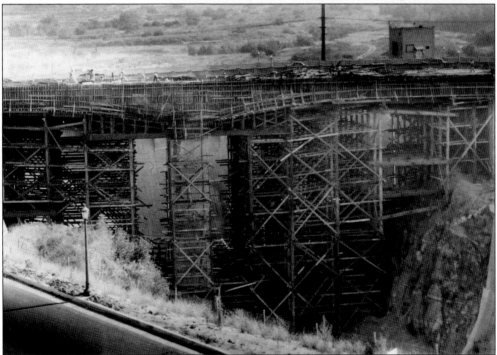

A new bridge across Devil's Gate was built in 1955 in front of the dam, which was constructed in 1920 after a devastating flood. (Courtesy of Glendale Public Library, Special Collections.)

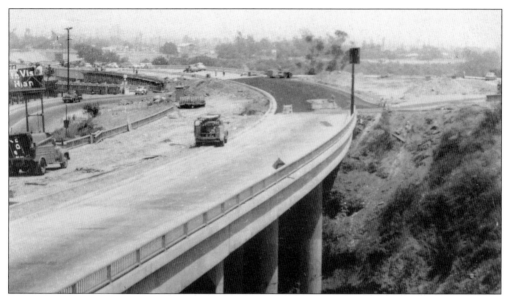

In August 1955, a new small freeway was built from La Cañada to Pasadena, which was called the Foothill Freeway. This August 1955 photograph shows the final phases of construction beyond the newly built bridge. While this construction was in progress, La Cañadans drove to Pasadena via Linda Vista. (Courtesy of Glendale Public Library, Special Collections.)

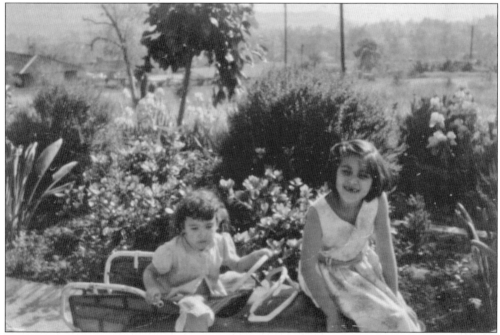

This photograph of Susy Ungermann (left) and Michelle McGrath looks southwest from the Pizzo house toward the Galvarys' property, across Angeles Crest Highway. The Galvarys had every farm animal imaginable in their barnyard. There were few houses in the northeastern La Cañada foothills before 1955. The lots on Pizzo Ranch Road would go to Bill Godbey, who later built the La Cañada Country Club development; Louis Pizzo's nephew Ray Contino and his family; and Louis and Vicenzina Pizzo's children. (Courtesy of the Pizzo family.)

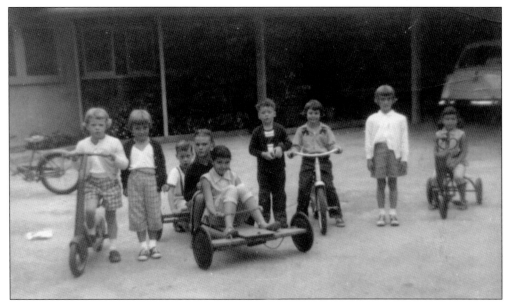

In the 1950s, Bob and Elizabeth Jones lived on the corner of Angeles Crest Highway and Harter Lane. The neighbor kids loved to come and play at the house because Mrs. Jones would call everyone to lunch on their "intercom." She could find anyone in any room of the house, the yard, or by the pool! This was the ultimate in technology. In this picture, the neighborhood gang includes: Barbara and Mike Butler, Sherri McGrath, (center, on the go-cart), Joyce Jones, Susy Ungermann (right), and Marcia Jones (left). (Courtesy of the Pizzo family.)

Bill McGrath and Louis Pizzo are leaning against a new Oldsmobile with white sidewall tires, which was bought at Paola Oldsmobile in nearby La Crescenta. Lillian Paola was Louis Pizzo's niece. She married Pete Paola, and they lived on Princess Anne Road in La Cañada. These Queen palm trees are still standing at 5230 Pizzo Ranch Road, but the sheep, goats, chickens, aviary, horse corral, and fruit and vegetable gardens are no longer there. (Courtesy of the Pizzo family.)

The Godbeys' house was built on the corner of Harter Lane and Pizzo Ranch Road in 1954. The Godbeys were the only family on the road who were not Pizzos. Bill Godbey was building houses in Anaheim, near Disneyland, before he began his golf course project in the 1960s in La Cañada. Mrs. Godbey and her daughter Charlotte often had matching hair and bows. Their Christmas trees were usually fashionably flocked white, or sometimes pink. Sometimes Mrs. Godbey's hair and the tree matched. One day, in 1958, it snowed again in La Cañada. (Courtesy of the Pizzo family.)

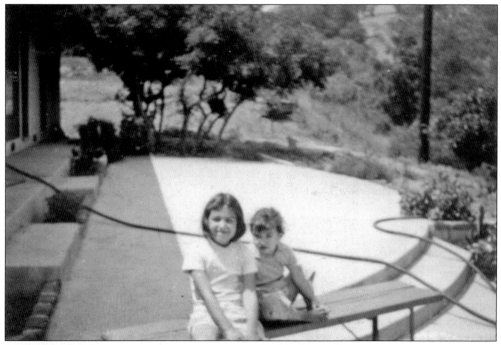

Michelle McGrath and Susy Ungermann are sitting on the McGraths' new concrete patio in the backyard, overlooking the canyon that their grandfather, Louis Pizzo, bought in 1950. (Courtesy of the Pizzo family.)

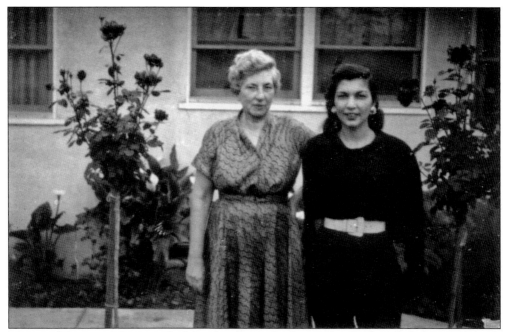

Mamma (Vicenzina) Pizzo cooked Sunday dinner Sicilian style, which included main and side dishes fresh from the garden. Family and friends were usually in and out all weekend for the food and Papa's homemade wine. Pictured here in the early 1950s are Vi and her daughter Mary (Pizzo) Ungermann in front of Mamma's kitchen. (Courtesy of the Pizzo family.)

Michelle McGrath is sitting on her mother's new green Buick Dynaflow, as she looks out over the deer meadow from the Pizzos' driveway in 1956. At the north end of the meadow were old hives inhabited by wild bees, which sometimes terrorized the families living below during the summers. The children learned about bees very quickly. This deer meadow became a housing development in 1965, with street names Briar Tree, Summit Crest, and Evening Canyon Drive. (Courtesy of the Pizzo family.)

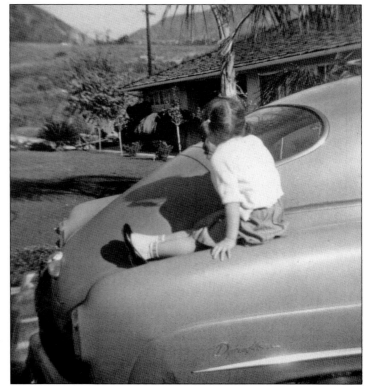

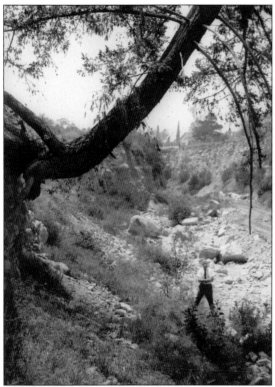

In May 1964, this man is standing in the watercourse of Pickens Canyon; it is practically dry. Quite a difference from the days when trout thrived in the stream. There are now debris basins in case of floods and fires. The weather continues to be unpredictable in La Cañada. (Courtesy of Glendale Public Library, Special Collections, George Ellison.)

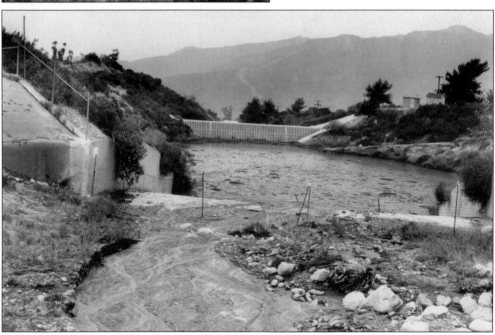

Debris basins were built after the 1930 and 1938 floods. This is the Pickens Canyon debris basin in 1965. Once the source of much of La Cañada's water, the mountain stream could now be caught in this basin to protect the many homes that were built in the valley below from flooding. (Courtesy of Glendale Public Library, Special Collections.)

In 1969, there were still a few natural watercourses. This is the Flint Wash before it was cemented. The bridge is on Berkshire Place. (Courtesy of Glendale Public Library, Special Collections.)

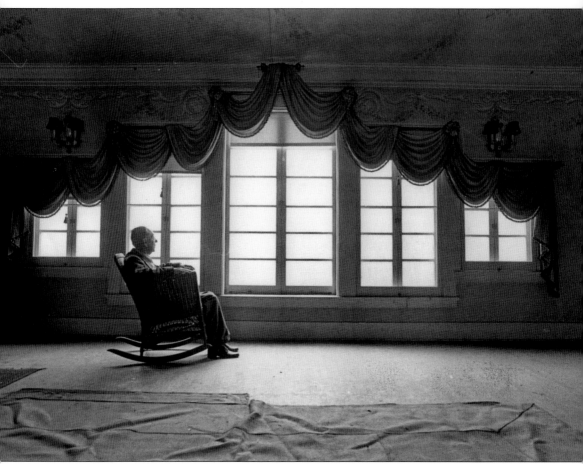

Lloyd Lanterman is looking out of the ballroom windows of El Retiro over what was left of the family domain. The Craftsman home was built by Roy Lanterman after he had returned from helping survivors of the San Francisco earthquake and resulting fires. He built it entirely out of concrete. This house is now a museum, the Lanterman House, dedicated to the preservation of La Cañada Flintridge history. It is open to the public, and it is located near Verdugo Road, which was once the driveway to the family home at 4420 Encinas Drive. (Courtesy of Glendale Public Library, Special Collections.)

Two

Ranches and Ranchers
Fruit of the Vine

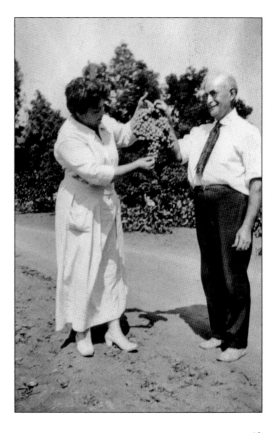

Lou and Dan Skuse are admiring this enormous bunch of table grapes. These are Morocco grapes, which were grown in front of the old Kirst house. The Kirsts grew a variety of grapes, including Tokay, Mission, Malaga, Madera, Concord, Cornishon, and Zinfandel. Cornishon Street was named for the Cornishon grapes, which the Petrottas grew on their ranch, south of Michigan Avenue in the area around the old junior high school. That area is now leased to several private schools. (Courtesy of the Kirst collection.)

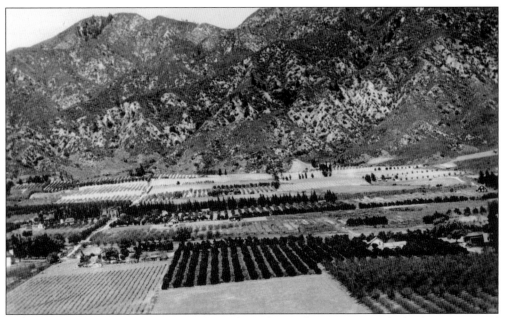

This photograph, taken from Robin Hill Road off Chevy Chase Drive, overlooks the western end of La Cañada, near what became the La Crescenta border when the Lantermans and Williams subdivided and sold the western end of the old Rancho La Cañada to Benjamin Briggs. One of the buildings on the right was the home of Henry Slutman. The Slutmans grew plums (that were dried into prunes) near where the Lanterman Auditorium was later built in the 1960s. (Courtesy of Glendale Public Library, Special Collections.)

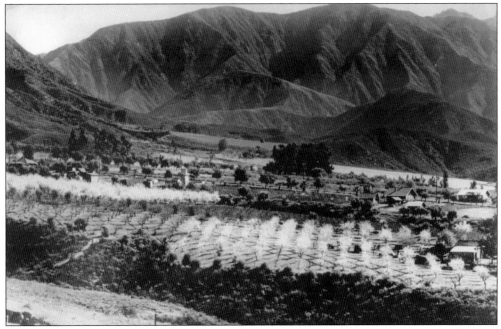

During spring in the 1920s, this is what the valley looked like after proper irrigation and a kind winter. The flowering trees are probably almonds, apricots, or other stone fruit. Prunes grew well in La Cañada. (Courtesy of Glendale Public Library, Special Collections.)

This road wound around where the 210 Freeway now sweeps toward Devil's Gate Dam into Pasadena. The Flintridge Golf Course was located on the right beyond the flowering fruit trees. Many La Cañadans enjoyed the fireworks displays that the golf course and country club provided for the valley during holidays and special occasions. (Courtesy of Glendale Public Library, Special Collections.)

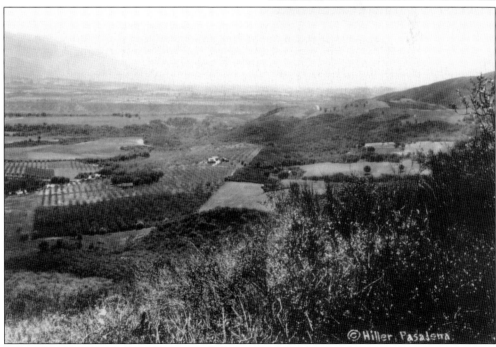

When standing on a hill in the San Rafaels, one could look toward Pasadena in the early 1900s and see nothing but orchards, vineyards, and a few houses. (Courtesy of Glendale Public Library, Special Collections.)

On the lower right, the unpaved road to the Flintridge Golf Course is visible as it passes through the fruit orchard, left, and the oaks, right. The road is lined with stones. There is still a road like this across from La Cañada High School in Hahamongna Park. In the foreground, is an empty lot, now precious in La Cañada. (Courtesy of Glendale Public Library, Special Collections.)

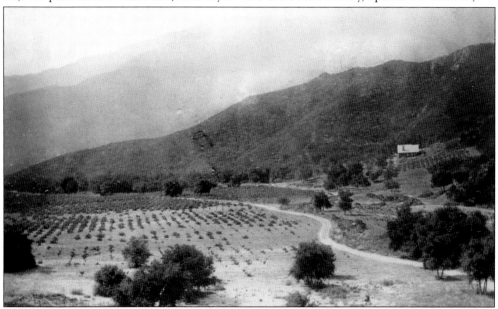

Grape vineyards were less dependent upon regular irrigation and could survive drought. This vineyard is clustered in oak trees, which thrive in similar environmental conditions. Some La Cañada homes still have the old grapevines and oaks in their yards, which have survived through periods of subdivision, relandscaping, and renovation since the photograph of this ranch (possibly Gould's) was taken. (Courtesy of Glendale Public Library, Special Collections.)

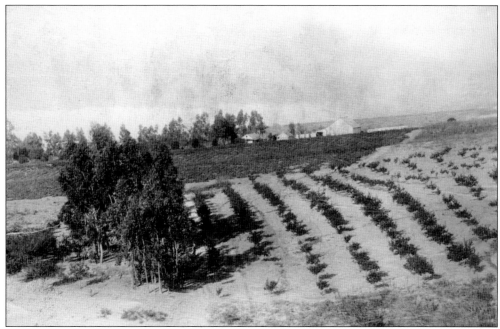

Eucalyptus trees were planted as windbreaks on the early ranches. As any new resident of La Cañada quickly learns, when the winds come down through the canyons, they come like a stampede at hurricane force. (Courtesy of Glendale Public Library, Special Collections.)

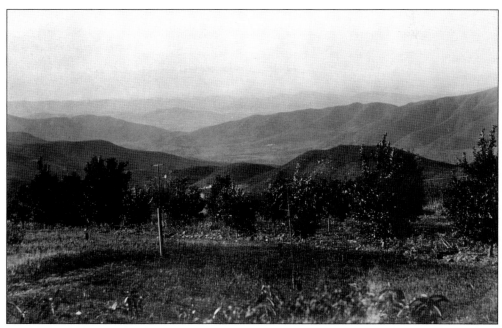

Much of the valley was also planted in oranges and other citrus. The Lantermans had lemons and grapefruit. Oranges and avocados were planted between what is now La Cañada Boulevard and Angeles Crest from Foothill Boulevard up to the actual foothills of the San Gabriels. (Courtesy of Glendale Public Library, Special Collections.)

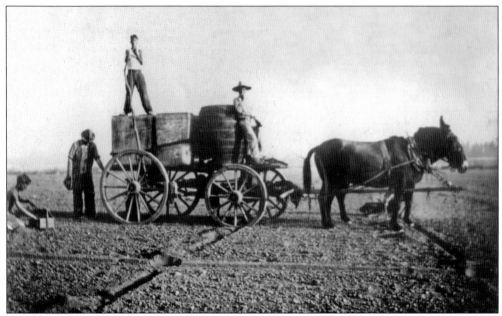

These mules are hauling water in the tomato fields at the north section of the Kirst Ranch, below where Gould Canyon Bridge on Angeles Crest Highway now arches over the canyon at Pizzo Ranch Road. (Courtesy of the Kirst collection.)

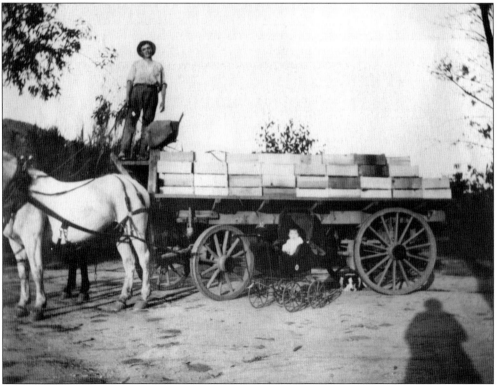

Burt Kirst has a load of grapes that are going to the Grand Central Market in downtown L.A. on Seventh and Central. (Courtesy of the Kirst collection.)

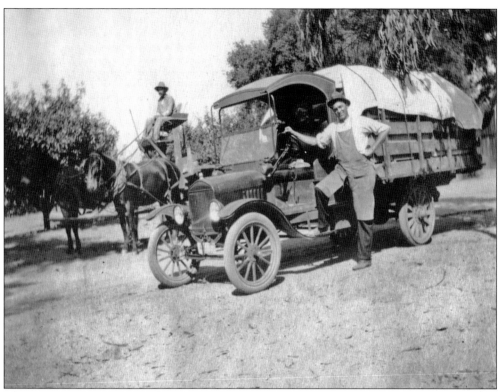

This is a picture of progress during grape season in 1918. The Model T Ford truck was able to carry many more boxes of grapes than the horse and wagon. (Courtesy of the Kirst collection.)

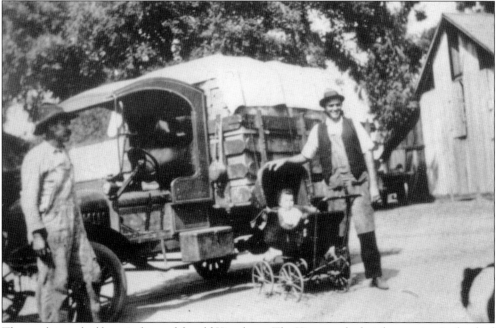

The truck is parked here in front of the old Kirst barn. The Kirsts made their home wine in the shed next to the barn—before and after Prohibition, of course. (Courtesy of the Kirst collection.)

Burt Kirst has just picked another large cluster of grapes. These are Morocco table grapes, grown at the old 90-acre ranch house before Burt and Gertrude moved down to their new house on Michigan Avenue. Behind Burt (right) is a telephone pole. The Kirsts had a telephone long before they had electricity. They cooked their food on a wood stove and used kerosene lamps with shiny chrome reflectors until the 1930s. Mrs. Knight would always phone the Kirsts whenever Whoopee ran through her pond and disturbed her fish on his way to the tomato fields. (Courtesy of the Kirst collection.)

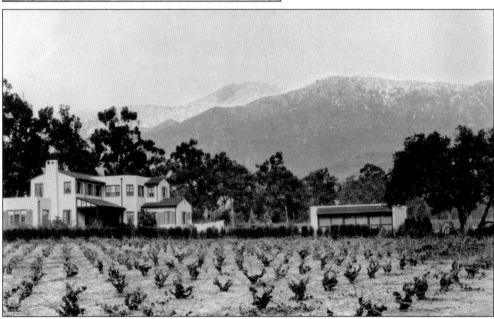

Vineyards surrounded the Kirst family house. These table grapes were just steps from the house in the Kirsts' backyard. Some friends of the Kirsts brought Whoopee to the Kirsts' house when he was a little puppy and left him in the three-car garage behind the house. When the Kirsts came home from working in the vineyards, Burt said, "Whoopee, there's a dog!" And that's how Whoopee got his name. (Courtesy of the Kirst collection.)

The truck is parked on the side of the road and set up to sell grapes and real beefsteak tomatoes. This is Betty Kirst, selling the produce. A three-pound basket of grapes sold for 10–15¢. At crop season, the Kirsts had two truck stands. Driving down Foothill from Pasadena toward La Crescenta, Cliff Kirst's first stand would be on Vineta. Betty had the second stand down the road. Driving further down the road would be the Slutmans' permanent stand, covered with palm fronds, on Indianola and Foothill. Then came the Rinettis' permanent stand. Since the Kirsts had two stands, the kids would sometimes play a game to see who could sell more. During the Depression, sometimes they made over $100 a week from the grape stands. (Courtesy of the Kirst collection.)

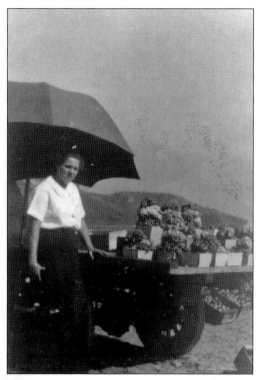

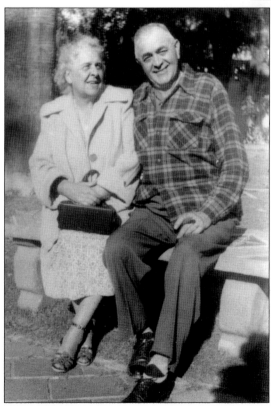

Burt and Gertrude Kirst are pictured here in the 1950s. (Courtesy of the Kirst collection.)

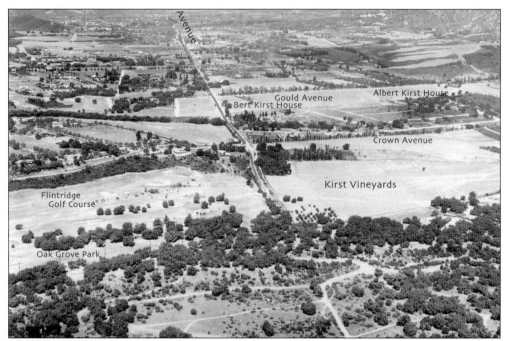

This is the La Cañada Valley looking northwest from Pasadena. Names have been added to show where various places were when the Kirsts owned their ranch. (Courtesy of the Kirst collection.)

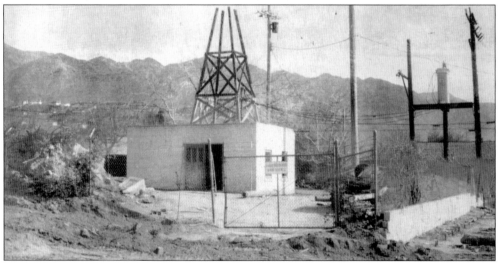

As the Kirst family's large ranch was gradually subdivided for houses, the old pump and well at the vineyards fell into disuse. The Kirsts' Cornishon grapes, now gone, had flourished just left of the well in this photograph. The Kirsts had always had water. They had obtained the water rights from the canyon above La Cañada Boulevard when they made their trade with the Ketchums in 1904. They brought water through a tunnel from the canyon and carried it by wagon, and later pipes. They dug their own well, and put in the first water pump at their ranch. This gave them the self-sufficiency that other La Cañadans would have loved to have had. Water, at times, was used as currency and had strategic value. (Courtesy La Cañada Irrigation; photograph by Doug Caister.)

Three

BUSINESS AND INDUSTRY
MICHIGAN AVENUE BECOMES
FOOTHILL BOULEVARD

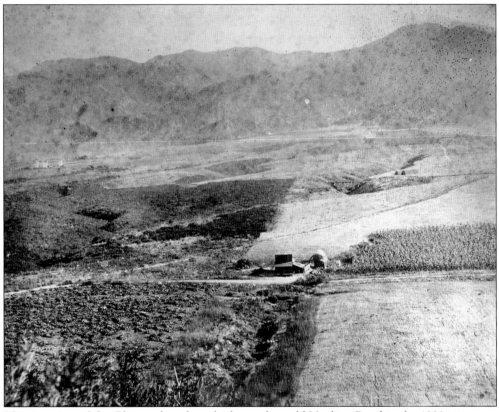

This is a view of the Chinese laundry, which stood on old Verdugo Road in the 1880s, just east of where the United Artists theaters now stands and across from Verdugo Hills Hospital. The Soledad grade road crosses the photograph diagonally on its course to the San Gabriel Mountains, where the last few remaining members of the Tongva (Gabrielino) tribes and banditos such as Vasquez hid. The El Camino Corto Bridge is in the center of the photograph. The Soledad grade was a partially completed project of Mormon engineers, who were building it as a freight artery to link Antelope Valley with the L.A. Basin. The project was abandoned when they reached the daunting San Gabriel Mountains, however. (Courtesy of Glendale Public Library, Special Collections.)

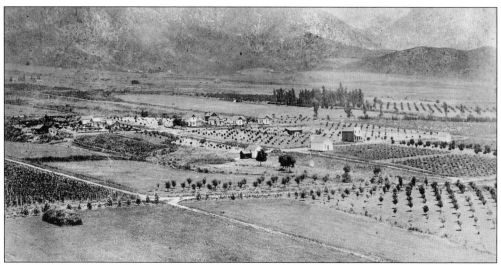

In 1888, this was La Cañada's business section at the intersection of Alta Canyada and Verdugo Roads, west of what is now Foothill Boulevard, where the Church of the Lighted Window stands today. This photograph was taken by Col. T. S. Hall, who climbed to a hilltop in the San Rafael Mountains (now on Descanso Gardens property) to get a bird's-eye view of the valley. The large grove of trees (center right) bordered the Ketchum property at that time. (Courtesy of Glendale Public Library, Special Collections.)

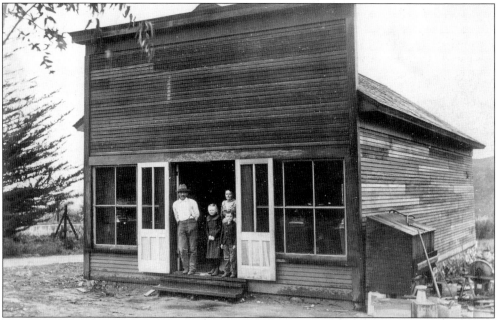

This 1898 supermarket sold fresh fish from the local mountain streams, local produce, and imports from Los Angeles and Pasadena. It stood on the corner of Michigan Avenue and Union Street. and served as the post office. For a time, it was a library as well. In 1898, the proprietor was S. S. Guderian, who is standing in the doorway with his family in this photograph. Later the proprietor was Harry Woodward, who added a second story. After that, the building became the Stultz General Store. The Lantermans' water reservoir was to the left of this building. (Courtesy of Glendale Public Library, Special Collections.)

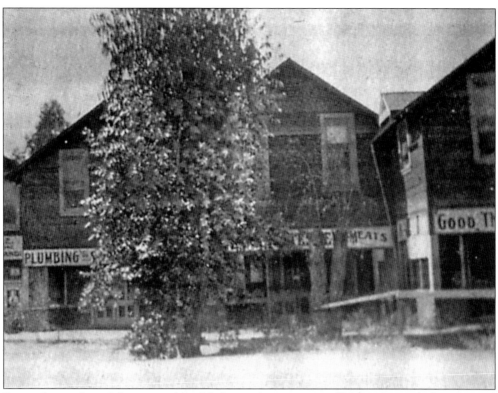

Pictured are a few of the stores along Michigan Avenue, west of Union Street, before the road was paved. (Courtesy of Virginia Robertson.)

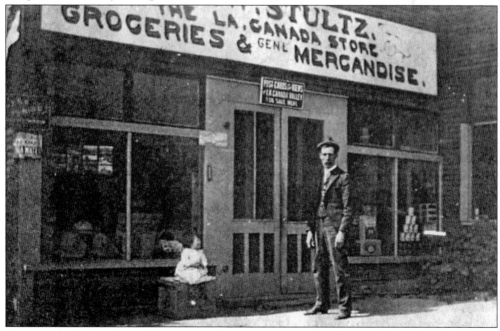

This was the Stultz General Store on Michigan Avenue in the 1920s, after the Woodwards left. (Courtesy of Virginia Robertson.)

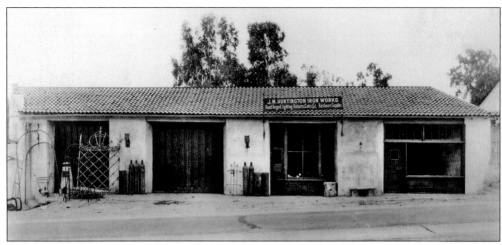

The Huntington Iron Works was built on old Michigan Avenue in the center of La Cañada's business district at the turn of the 19th century. The iron gate in this photograph, near some gas tanks, may have been created or repaired at the shop. From near and far, customers traveled down this one-lane road for Huntington's design, casting, and welding services. (Courtesy of Lanterman Historical Museum Foundation.)

HUNTINGTON

Since 1914 this name has progressed with the Valley of La Cañada and has been a part of its rapid development.

Our Barbecue Equipment and Charcoal Broilers have led a fast growing National Enterprise of outdoor living and home recreation. . . . La Canada is the birthplace of Portable Barbecues.

The HUNTINGTON is

First in Cooking Efficiency
First in Convenience
First in Long-life Service
First in Safety

J. M. Huntington Iron Works

1428 Foothill Blvd. SYlvan 0-1301

This advertisement was in one of Lanterman's development brochures in the late 1930s or early 1940s. The Huntingtons lived in the back of the iron works on Belleview Avenue (now Curran Street). The elder Mr. Huntington, Jim, bought the family home and founded the Huntington Iron Works in 1914. Before the newlywed Huntingtons came from Boston, the house had to be refit to its foundation because a flood had moved it off slightly. Mrs. Huntington was said to have had a rough time adjusting to her new lifestyle, but became happier when electricity was installed. The Huntingtons patented a very popular barbecue that they designed in 1936. It was made at the iron works until the 1960s. (Courtesy of Glendale Public Library, Special Collections.)

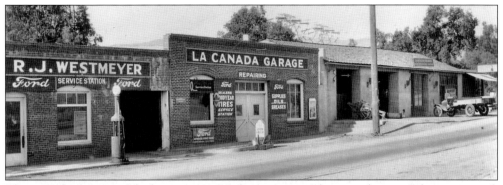

This view shows more of the businesses in Michigan Avenue's business district. A fancy new truck is parked in front of Huntington Iron Works. Note that all of these businesses center around automobiles. The Westmeyers lived on Alta Canyada, just north of Michigan Avenue. (Courtesy of Glendale Public Library, Special Collections.)

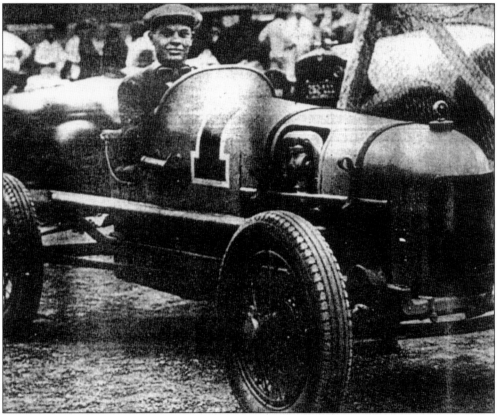

Ed Winfield was born in La Cañada and attended La Cañada School through all eight grades before devoting himself to racecars. He developed camshafts and carburetors for Indy 500 drivers from 1925 to 1941, and most of them were winners. Peter De Paolo, Ralph De Palma, and Pat Flaherty were a few of the drivers that used Winfield's products. The Winfield family lived on Curran Street, just behind the Huntington Iron Works, which was on Michigan Avenue. Ed's mother worked at the La Cañada School and was also in charge of opening the water gates of the reservoir for the homes each week. If she forgot, there would be no water for the whole area. (Courtesy of Virginia Robertson.)

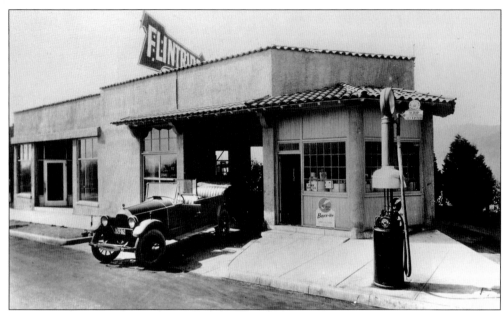

Another mechanical wizard was Whytie Womack. He was, at first, both the mechanic and chauffeur for the Flint Garage and Stables, which became the Flintridge Garage and Service Station. Flint had a realtor's office in Los Angeles, where he directed prospective buyers to the garage. From there, the new home shoppers could park their cars, and Whytie would chauffeur as he gave a guided tour of the town and his properties. (Courtesy of Lanterman Historical Museum Foundation.)

Whytie Womack also built racecars on the side. He lived on Bel Aire Drive, near the Flintridge Garage, pictured here on Michigan Avenue and Haskell Street (now Angeles Crest Highway). Haskell Street began just behind where the tall tree is standing on the right in the photograph. (Courtesy of Lanterman Historical Museum Foundation.)

This Flintridge Service Station, probably the one on the northwest corner of Commonwealth (previously Texas) and Foothill (previously Michigan), was owned and operated by Ralph and Earl Cornwell. (Courtesy of Don Birchall.)

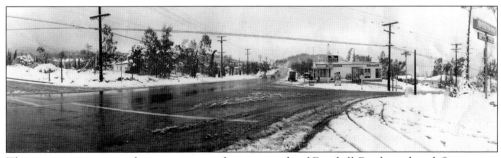

This service station in the snow was at the crossroads of Foothill Boulevard and Oceanview Boulevard. (Courtesy of La Cañada Irrigation, W. H. Ink Collections.)

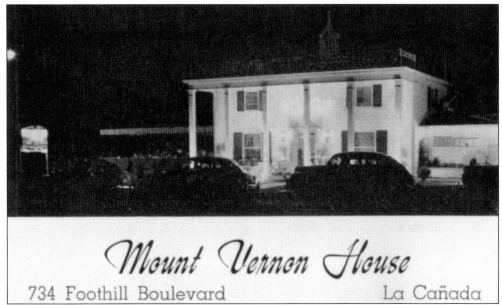

Mount Vernon House

734 Foothill Boulevard La Cañada

The Mount Vernon House (1930s–1940s) was a restaurant located on Foothill Boulevard in front of the Thursday Club on Woodleigh Lane. (Courtesy of Glendale Public Library, Special Collections.)

La Cañada Feed and Seed was where everyone in town got their garden supplies and feed for their livestock and pets (c. 1940). It stood where the Sports Chalet Ski Shop is presently located. Peter Prescott's office was located near where La Cañada Hardware stood for so many years from the 1940s up until the beginning of the 21st century. Now Curves occupies the building. (Courtesy of Glendale Public Library, Special Collections.)

Flintridge House was located on the north side of Foothill Boulevard, east of La Cañada Feed and Seed, between Angeles Crest Highway and Commonwealth (c. 1940). (Courtesy of Glendale Public Library, Special Collections.)

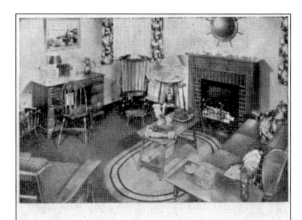

Featuring quaint Provincial, gracious 18th Century . . . famous names such as Indianapolis Chair, Wm. A. Berkey, Zangerle, etc.; all familiar to the lovers of fine furniture. Plus our own **complete** Decorators Service. Color-coordinated fabrics a specialty.

SYlvan 0-1906

951 FOOTHILL BLVD.
La Cañada

Flintridge House

FURNITURE - INTERIORS

"For that real home cooked chicken dinner . . ."
Serving a discriminating public.
Dinners 5 to 8 - Sundays 12 to 8 - Closed Mondays

556 Foothill *Edge of Town House* SYlvan 0-1744

The Edge of Town House, pictured here c. 1940, was on the east side of town on Foothill Boulevard, two blocks east of the Mount Vernon House. (Courtesy of Glendale Public Library, Special Collections.)

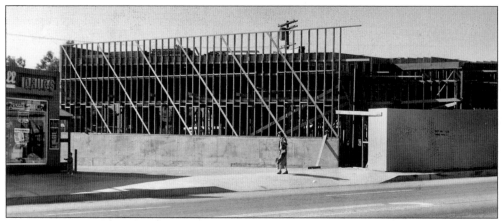

This new building, going up next to Rexall Drug Store, sits on the south side of Foothill Boulevard in the 1940s. (Courtesy of Glendale Public Library, Special Collections.)

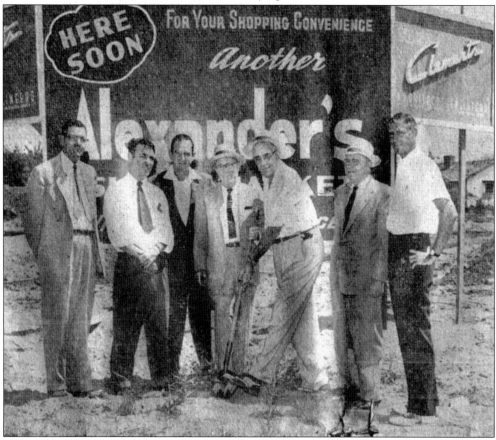

Burt Kirst, center, between the Alexander brothers, digs the first shovelful at the groundbreaking of Alexander's Market on Foothill Boulevard. Burt died about a week after this 1955 photograph was taken for the newspaper. The newspaper was printed in April 1956. Phil Kirst is pictured at the far right. From the beginning, it had been Burt Kirst's vision to build a shopping center on Foothill Boulevard. The Kirst family leased the shopping center properties to various tenants. (Courtesy of the Kirst collection.)

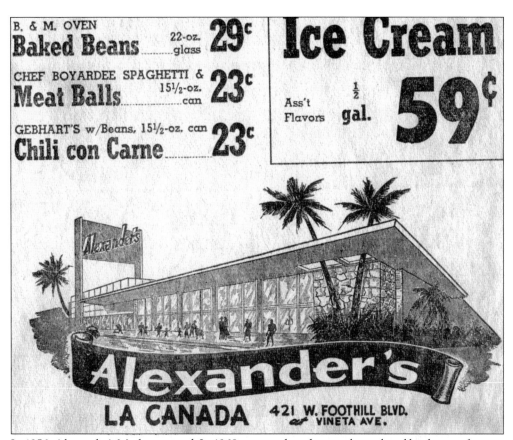

In 1956, Alexander's Market opened. In 1968, it was taken down to be replaced by the new freeway going through the center of town. (Courtesy of the Kirst collection.)

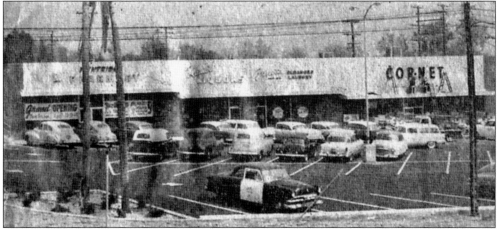

This was a typical day at Alexander's Shopping Center. During the 1950s, the parking lot was filled with cars. Ed Kraus owned and operated the liquor store; the Flintridge Pharmacy was more often called "Jundt's," after the owner and pharmacist; and Cornet gave the La Cañada Variety some competition. But the Variety had an advantage being next to La Cañada Elementary School and the junior high school, which later became Foothill Intermediate School. (Courtesy of the Kirst collection.)

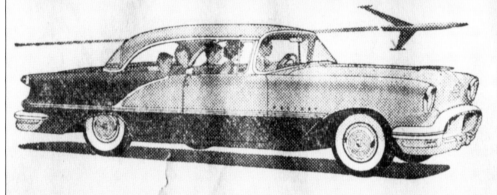
Lillian (Pizzo) Paola's husband owned and operated Paola Oldsmobile with his brother Linc. Pete and Lillian lived on Princess Anne Road with their daughter Philipa. This is a 1956 Oldsmobile, with white sidewall tires. Comparing it to a rocket meant that it was the ultimate in technology and fast, which was important during the "race to space" of the 1950s. It wasn't until the 1960s that some people started thinking that it might be good to slow down. (Courtesy of the Kirst collection.)

Four

FORMING A COMMUNITY
SCHOOLS, CHURCHES, POST OFFICE, (NO CEMETERY)

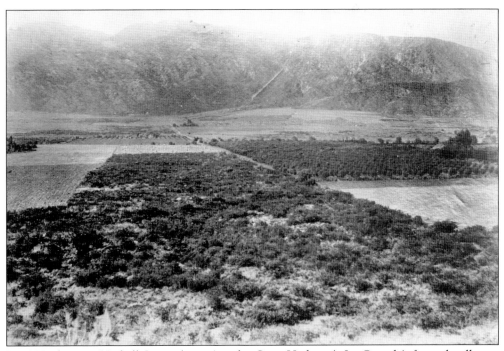

In 1892, this was Haskell Street (now Angeles Crest Highway). La Cañada's first schoolhouse (not to be confused with the later one on School Road) can be seen on the extreme far right of the photograph. (Courtesy of Glendale Public Library, Special Collections.)

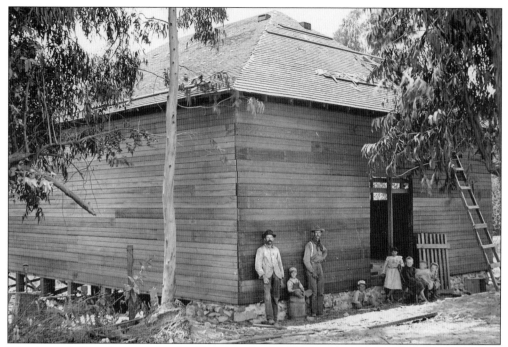

The dance hall and community building was built after the school board bolted the desks to the floor in the schoolhouse so that no more dances could be held there. The new dance hall stood on Michigan Avenue, just west of the Church of the Lighted Window. It was said to have been built from the recycled bridge timbers that were removed from Michigan Avenue after the canyons were filled. (Courtesy of Don Birchall.)

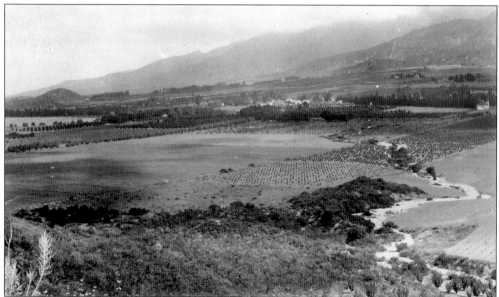

This road on the right lead from Pasadena into La Cañada when the schoolhouse was on the east side of town. The schoolhouse is on the right side of the photograph. Brown Hill can be seen in the distance (left), where the YMCA was built in the 1960s. (Courtesy of Glendale Public Library, Special Collections.)

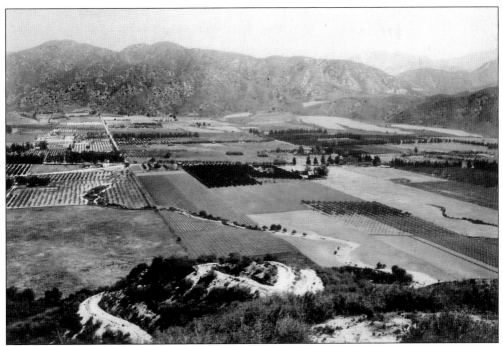

This view of the same road is taken from a different direction. The road meanders, as if it may have been cut by a stream or may have been an old deer trail. (Courtesy of Glendale Public Library, Special Collections.)

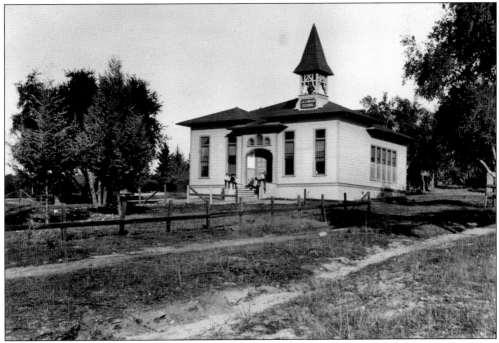

This two-room schoolhouse stood on Michigan Avenue and School Road from 1894 to 1917. It was built after the first schoolhouse on Commonwealth and Michigan Avenue burned down in 1893. (Courtesy of Don Birchall.)

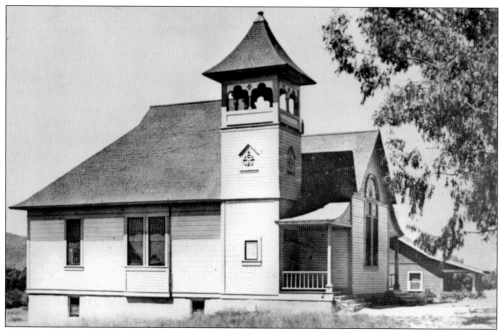

In 1897, the Community Church was La Cañada's first church, and it was dedicated in 1898. It was rebuilt in 1924, and when the stained glass windows were installed in 1925, it was renamed The Church of the Lighted Window. (Courtesy of Glendale Public Library, Special Collections.)

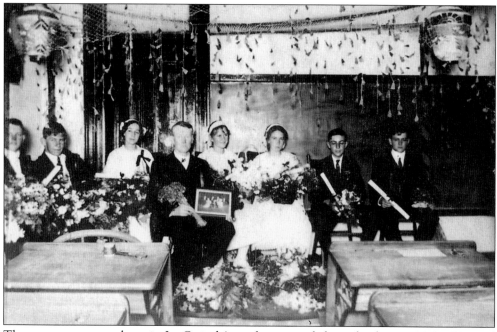

There were seven students in La Cañada's graduating eighth-grade class in 1912—Howard Stickney, Marion Lea, Mildred Bolton, Catherine Green, Clara Armstrong, Sam Durand, and Maurice Davenport. The teacher, C. D. Poore, is sitting in the middle. (Courtesy of Glendale Public Library, Special Collections.)

Many La Cañadans fondly remember the Thursday Club at 4440 Woodleigh Lane because this is where they had their cotillion classes. It was here that Mr. and Mrs. Gallotz would teach young girls and boys ballroom dancing. The building was actually built in 1926 for the first Women's Club in La Cañada, which was founded by Mrs. Jesse Knight in 1912. (Courtesy of Virginia Robertson.)

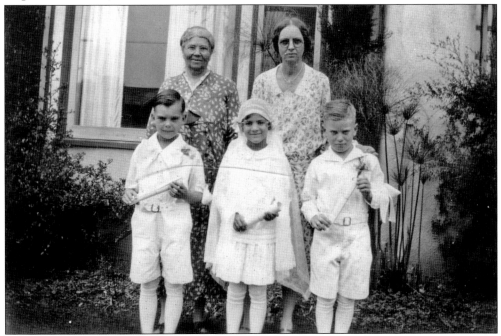

Some La Cañada children are standing in front of the their house after communion. Before St. Bede's Church was built, the closest Catholic churches were in Montrose and Pasadena. There was only the Community Church in town and no graveyards or cemeteries. Many La Cañadans traveled to other towns for religious services. (Courtesy of the Kirst family.)

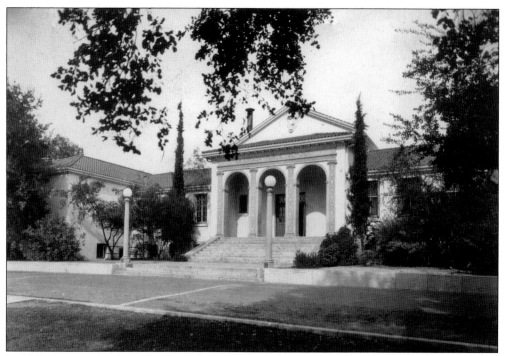

In 1919, a new school was built on the same property as the second schoolhouse. The town had outgrown a two-room schoolhouse. This one had an administrative office and classrooms. (Courtesy of Glendale Public Library, Special Collections.)

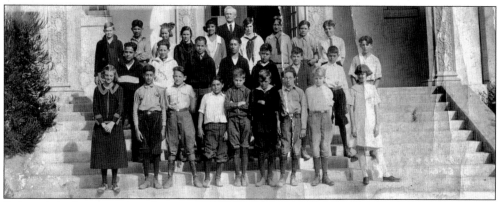

Principal Andrews stands at the rear center of this graduating class of 1920 at La Cañada School. Pictured, from left to right, are (first row) Josephine Hokey, Sylvain Medina, Billy Banks, Nonie Facular, Kenneth McClaren, Donald Stafford, Charles Hansen, Bert Leonard, Zelma Peet; (second row) Frank Calderon, Bill Graves, Parke Wood, Joe Medina, Robert Slutman, Robert Moses, William Morehouse, Delmar Potts; and (third row) John Calmer, Santana Krista, Helen Ducker, Margery Simpson, Lola Krista, Julia Oliver, Margaret Beene, Frank Peet, and Frank Chase. (Courtesy of Glendale Public Library, Special Collections.)

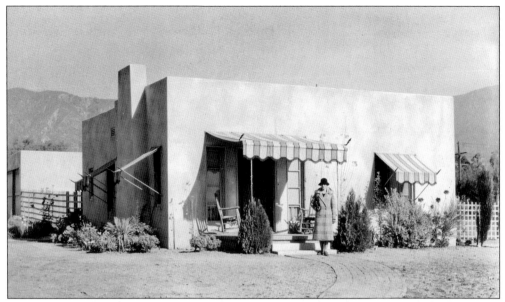

More people began to move into the community as the property was developed and sold by the Flints, the Lantermans, and others. This is one of the small Flintridge homes sold on Central Place in the 1920s. Central Place was renamed Bel Aire Drive in the 1930s. (Courtesy of Lanterman Historical Museum Foundation.)

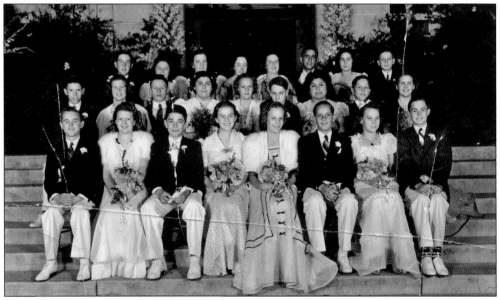

Although the town had grown, Cliff Kirst's graduating class in 1939 was about the same size as the class of 1920. The old traditions for celebrations were observed at the ceremony. On either side of the school entrance are large racemes of the Yucca that grow in the surrounding La Cañada Mountains. The front portico of the school building had been removed. Among those pictured in the class of 1939 are Charles McLaughlin, Dorothy Loundsbury, Nancy Northrup, Patsy Brown, Jerry Spangler, Cliff Kirst, Richard Gault, Christina Messina, Patricia Repath, the Le Claire twins, Carl Forseman, Byron Beech, Kate Kingsley, Karl Hammer, Susie Sugden, Ted Tiber, Helen Sheedy, and Maynard Garrison. (Courtesy of the Kirst collection.)

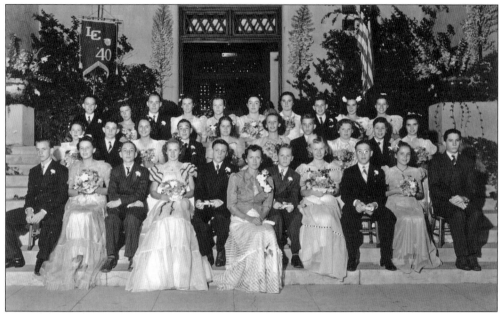

In the 1940 graduation photograph, the same traditions are upheld, with the addition of a banner for the year. This class is a little bigger, possibly beginning to reflect the growth in the town's population. It is a milestone worthy of the finest formal attire. The girls all hold bouquets. Notice that the fashion had changed for the boys from the year before, when they all wore white shoes and white pants. Or was this ceremony held later in the evening? (Courtesy of Glendale Public Library, Special Collections.)

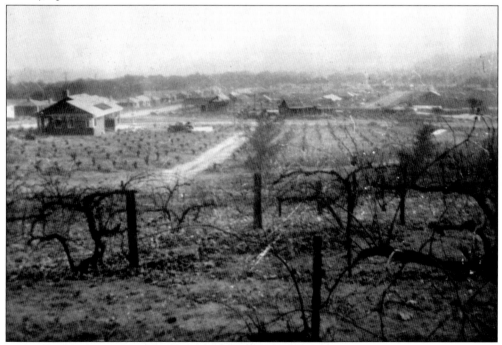

Pictured on the east side is the first development of the Kirsts' property in 1945, above where La Cañada High School was built in the 1960s. (Courtesy of the Kirst collection.)

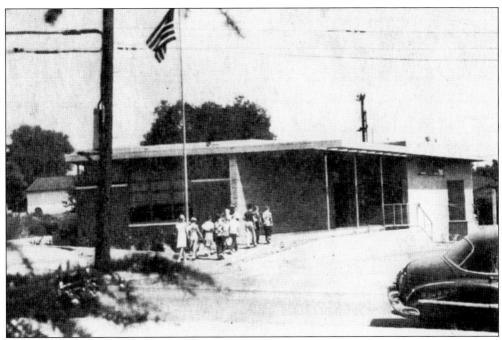

The La Cañada Public Library was located at 4510 La Cañada Boulevard, across the street from La Cañada Elementary School from the 1940s to the early 1960s. (Courtesy of Glendale Public Library, Special Collections.)

The second-grade playground at La Cañada Elementary School was bordered by homes in the Lasheart neighborhood. The second graders liked to stand by the fence and drink the honey from the honeysuckle flowers on the vines. Girls were only allowed to wear pants on special days. In the 1950s, Dr. Purdy's office, the school doctor, was next door on Foothill Boulevard. The remnants of the second old schoolhouse were at the edge of the playground and used as a custodian's supply room and workshop. (Courtesy of the Pizzo family.)

The bars were some of the best "hangouts" on the second-grade playground. The rings were also a favorite. The playground beyond the bars is for the first grade, which bordered the kindergarten. On the right, the windows of Dr. Purdy's office are visible. All of this was removed for the freeway in the 1960s, making it difficult to remember how important saddle shoes were for girls in the 1950s. (Courtesy of the Pizzo family.)

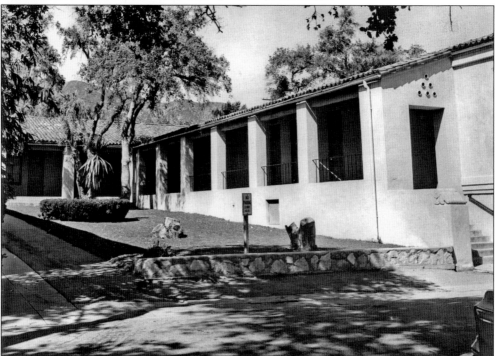

These were some of the classrooms at the rapidly growing La Cañada Elementary School in 1956. New schools—Paradise Canyon, Palm Crest, and Oak Grove—were built to handle the baby boom. La Cañada Junior High School was also built on Cornishon Avenue. No longer could all of the children in town fit in one school building. (Courtesy of Glendale Public Library, Special Collections.)

Ray Contino is late for a family baptism at St. Bede's Church at the east end of Foothill Boulevard. A bridge has been built over the new Foothill Freeway, an interim freeway to Pasadena before the 210 was constructed. The San Rafaels and Sacred Heart Academy are visible in the distance. (Courtesy of the Pizzo family.)

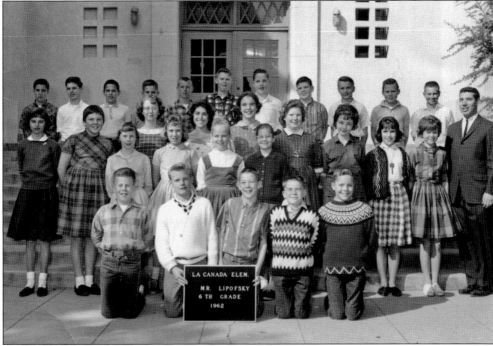

Mr. Lipofsky's sixth-grade class in 1962 are Daniel Brust, Gary McClellan, Bob Taylor, Kenny Hilton, John Vennard, Craig Lee, Dennis Watson, Ronnie Flinders, Jim Walton, Bill Godbey Jr., Nancy Baker, Penny Kelley, Marilyn Richardson, Susy Ungermann, Catherine Cheeley, Mary Ellen Mendel, Sandra Hobson, Erin Flanagan, Martin Lipofsky, Bonnie Cheesewright, Debbie Black, Claudia Early, Cynthia Grey, Doug Frank, Loren Woods, Richard Muelder, Kent Ambrose, and Kirk Moore. (Courtesy of the Pizzo family.)

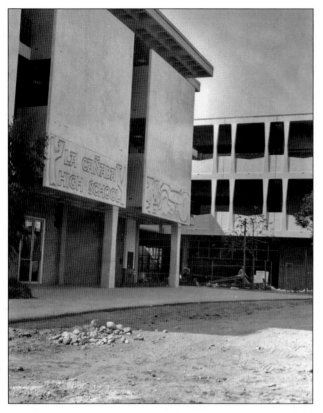

High-school students went to Glendale until 1920. After that, they went to John Muir High School until 1964, when La Cañada built its own high school. At that time, the area was still known as La Cañada, the name given to the valley when it was part of Rancho Verdugo in the 1800s. The children who lived in the residential neighborhoods of Alta Canyada and Flintridge, whose boundaries had always been loosely defined, went to either La Cañada public schools, or private ones. La Cañada High School was built on Spaulding Field (also known as "Skunk Hollow") and was nearing completion at the time of this 1963 photograph. (Courtesy of Glendale Public Library, Special Collections.)

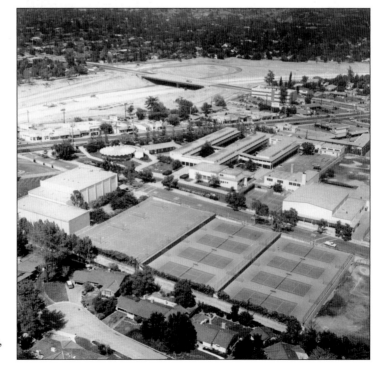

This is an aerial photograph of the community being divided by the 210 Freeway. Construction of the Angeles Crest overpass is visible in the top center. Foothill is just below the new freeway. The buildings in the foreground are La Cañada Junior High School (which became Foothill Intermediate in 1964, and later was rented by the city to private schools) and Lanterman Auditorium to the left of the tennis courts. (Courtesy of Glendale Public Library, Special Collections.)

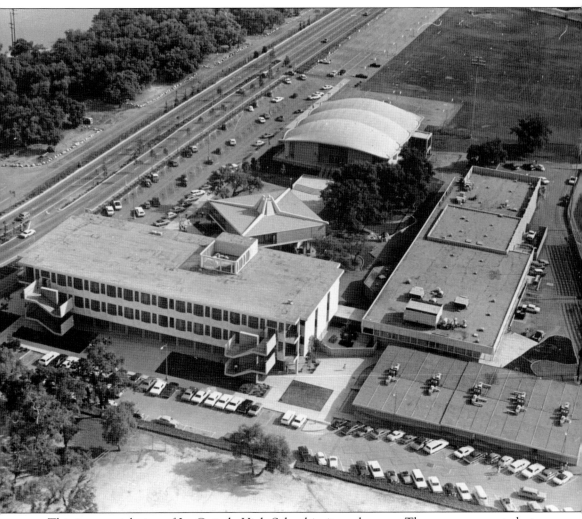

This is an aerial view of La Cañada High School in its early years. There were more students than the district had anticipated, and temporary classrooms (lower right) had to be set up in the rear parking lot (c. 1967). Other buildings have been added since. (Courtesy of Glendale Public Library, Special Collections.)

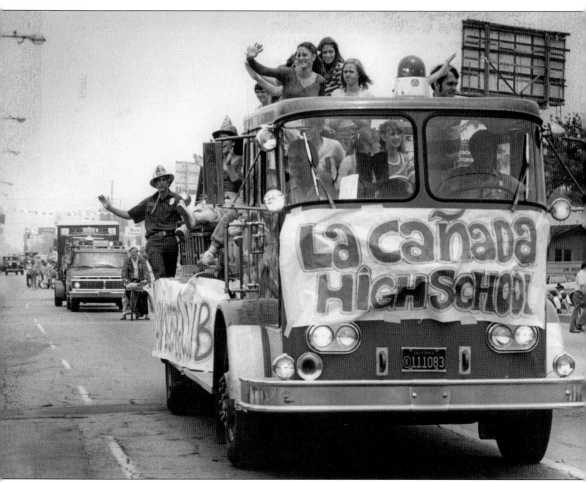

After the creation of the 210 Freeway, the community began to heal the rift, by celebrating the third week in May as its Fiesta Days to commemorate its old La Cañada beginnings and bring the whole community together for a barbecue and parade. This photograph of the parade was taken in 1981. (Courtesy of Glendale Public Library, Special Collections.)

Five

BIG ONES
STATESMEN, POLITICIANS, INVESTORS, ENTREPRENEURS, AND THE MOVIES

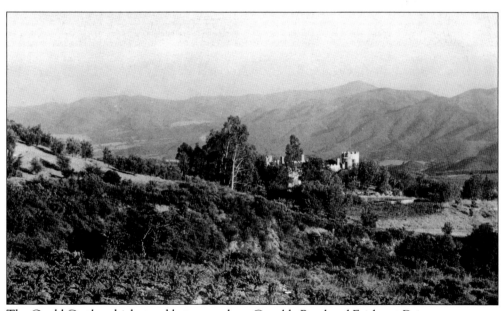

The Gould Castle, which stood between where Canalda Road and Fairhurst Drive are now, was on the hillside, north of Castle Road and east of Oceanview Boulevard. A pine tree is all that remains of this scene. (Courtesy of Glendale Public Library, Special Collections.)

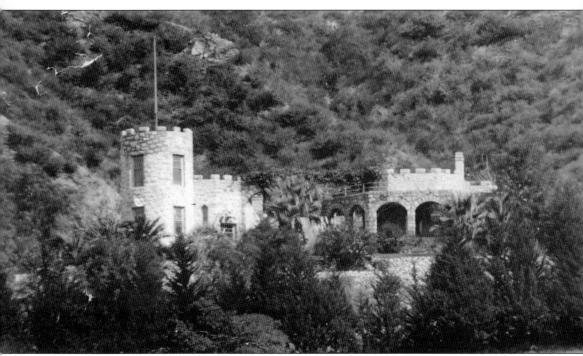

This is a 1908 close-up of the Gould Castle, built by Eugene H. Gould, who bought 185 acres near Pickens Canyon on which to build a winter home for his wife, May. Gould designed the structure to replicate a castle that May had seen in Spain, and construction was completed in 1892. Rare plants were planted in the central patio, and koi swam in the pond. The walls were all cut of native granite from the nearby hills using an ancient technique of drilling holes along the line—cutting and using wedges and "feathers" to split the stone. It is important to remember the local stonemasons of the time. Their fine craftsmanship is still present in some of the walls in La Cañada, La Crescenta, Glendale, and Pasadena. One of the stonemasons is only remembered by the name Elliot. Elliot cut all of the granite blocks for the castle. It was said that he had been a petty officer with the Royal British Navy, that he had fought American Indians, and that he had been a buffalo-hide hunter before mining in the gold rush. But this has not been verified. His workmanship on the Gould Castle would be enough for most. Another stonemason of the time, who laid loose rock walls, was Gustave Escale. (Courtesy of Glendale Public Library, Special Collections.)

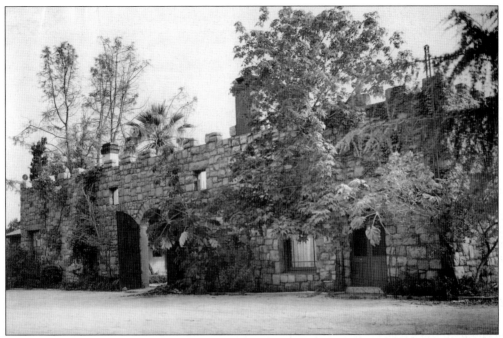

The Goulds lost the castle when Eugene Gould failed to corner the raisin market. The property went to the mortgage owners, the Cohens, who lived in Alameda. After that, there were quite a few tenants and potential buyers. Several Hollywood movies were made there. Frank Strong from another nearby castle offered to buy it for $200,000 but was refused. During the Depression, the Cohens sold the castle for $15,000. (Courtesy of Glendale Public Library, Special Collections.)

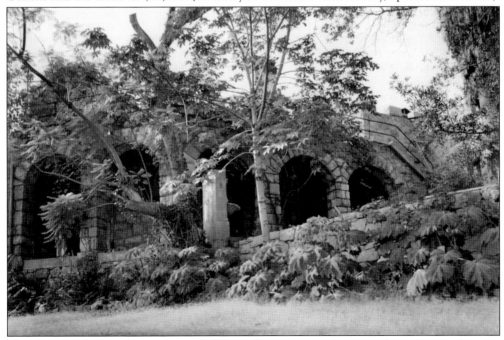

This photograph was taken as the castle fell into disrepair. It was later torn down for a new housing development. (Courtesy of Glendale Public Library, Special Collections.)

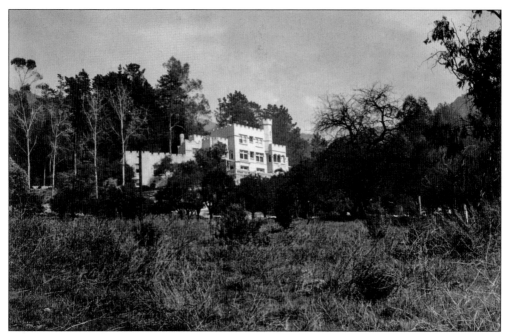

Lieutenant Governor Wallace built this castle. It later became "Strong Castle," for the next family who owned it, and after that, it became the "Pink Castle." (Courtesy of Glendale Public Library, Special Collections.)

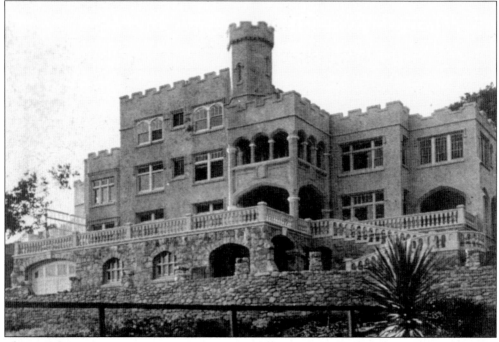

This was the entrance to Lieutenant Governor Wallace's castle. It was built in 1911 as a replica of the Carnegie Castle in Scotland on approximately 75 acres of grape vineyards, which he replaced with orange and other citrus groves. (Courtesy of Glendale Public Library, Special Collections.)

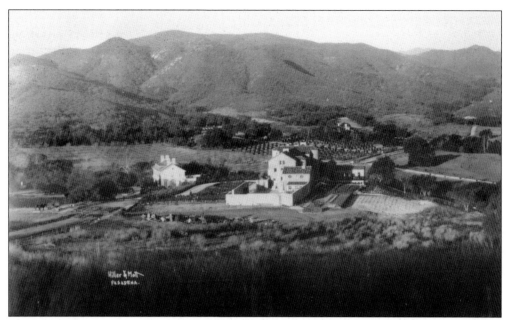

The Myron Hunt Colonial on the left was built for the Juttens at 757 Hillcrest. The larger house on the right belonged to the Jorgensens. (Courtesy of Glendale Public Library, Special Collections.)

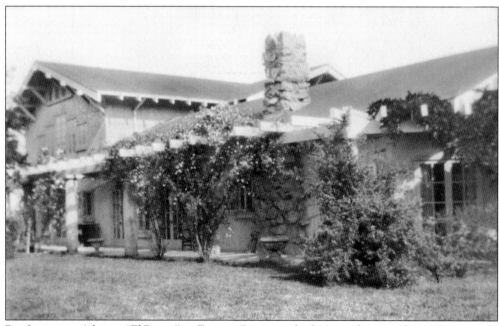

Ray Lanterman's home, "El Retiro" on Encinas Drive, was built across the street from "Homewood," Jacob and Amoretta's family home. It was completed in 1915.

This house was built in 1912 as a mountain retreat for geologist/oilman Bert Morrison. He sold it two years later to John Bullock, of Bullock's Department Stores, who used it as a winter recreation house. For tax purposes, the property was put in Louise Bullock's name, and when John Bullock died in 1933, he left the house to Louise. She had many parties in this house, some of them with themes involving costumes. Many of the guests were Hollywood celebrities. The property was surrounded by gardens, an aviary, and fountains. The fireplace was made with local Batchelder tiles. In 1955, the house was taken by eminent domain, for school district use. Now, in 2006, the house is once again up for sale. Hopefully, it will be restored and its rich history and unique local craftsmanship can continue to be enjoyed. (Courtesy of Glendale Public Library, Special Collections.)

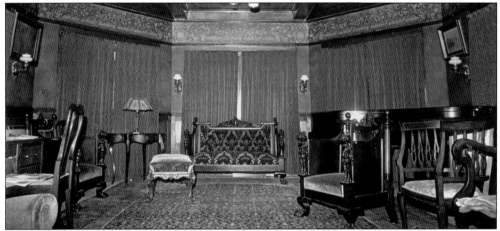

This view of a downstairs room in El Retiro, Roy Lanterman's home, is now the Lanterman House, a historical museum. Most of the furnishings in the photograph can still be seen at the restored site, as many of the household items had been left untouched for many years or were in storage in the closets and basement. The last remaining Lanterman brothers left the house virtually unchanged from the time Roy Lanterman built the house after giving his services as a physician during the San Francisco earthquake and fires. (Courtesy of Glendale Public Library, Special Collections.)

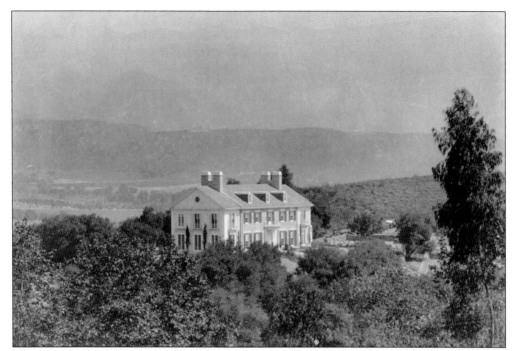

This was the Jutten house in 1918. Jutten was an employee of the Flints in the development of their Flintridge project. The view looks over the valley, toward the San Gabriel Mountains, where Angeles Crest was later built to penetrate the rugged terrain and facilitate travel, give access to the deserts on the other side of the mountains, and provide recreational use for the growing Los Angeles population. (Courtesy of California State Library Picture Catalog.)

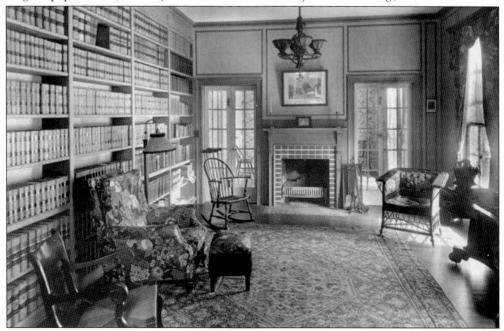

This is the Jutten library as it looked in 1919. Myron Hunt designed this house for the Juttens. (Courtesy of California State Library Picture Catalog.)

This was the entrance to the drive that led to the Juttens' house in 1919. (Courtesy of California State Library Picture Catalog.)

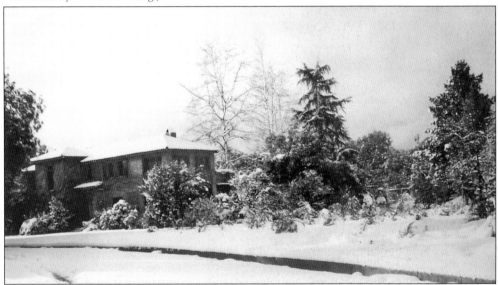

In 1926, this Flintridge home made headlines in the *Pasadena Evening Post*. It was raided and found to be operating as one of the largest whiskey manufacturing plants in Southern California. The owners of the estate were away in Europe. The bootleggers manufactured and bottled the whiskey on the second floor. A tower on the upper floor was used as a lookout, equipped with a buzzer system, field glasses, and an arsenal. The confiscated whiskey was valued at over $40,000. (Courtesy of the MacConnell family.)

In 1918, this Batchelder tile and molded-concrete mantel was photographed at the McNaughton home. (Courtesy of California State Library Picture Catalog.)

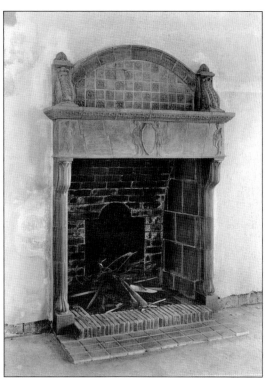

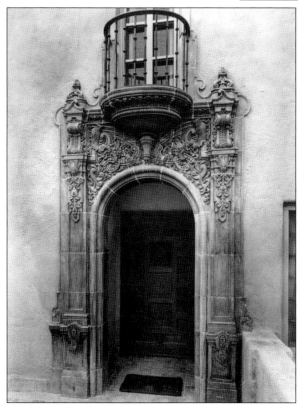

This ornately molded concrete entrance to the McNaughton home also used Batchelder tiles. McNaughton reportedly made his fortune through ownership of a department store chain, as did the Penneys (Villa Elena at Alta Canyada and Fairmount) and Bullocks, who also built homes on the west side of La Cañada. (Courtesy of California State Library Picture Catalog.)

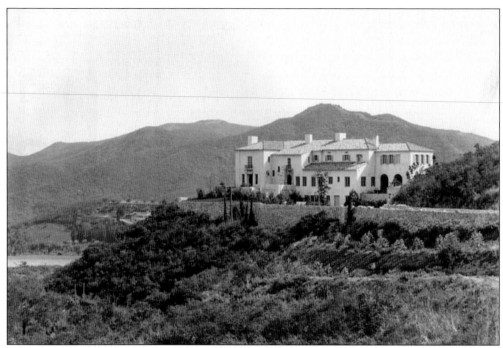

The McNaughton home was located at 1850 Foothill Boulevard on a hill near where the 2 Freeway ends at the foot of Palm Drive. Reginald Johnson was the architect of this home, built before 1919. (Courtesy of California State Library Picture Catalog.)

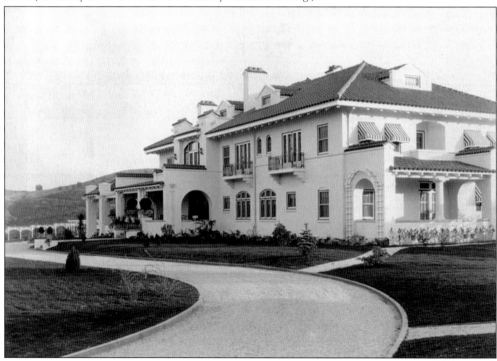

The house at 700 Berkshire Avenue is now known as Dryborough Hall. The photograph was taken in 1919, when the Riggs lived there. (Courtesy of California State Library Picture Catalog.)

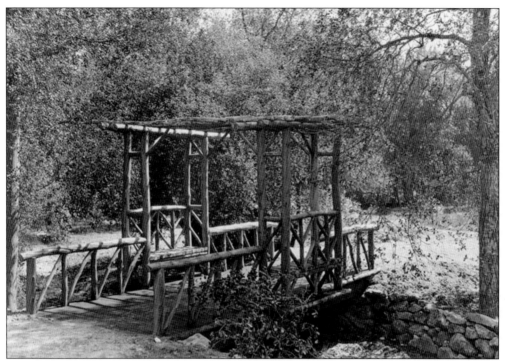

This was the bridge over the stream on the Riggs' property, *c.* 1919. (Courtesy of California State Library Picture Catalog.)

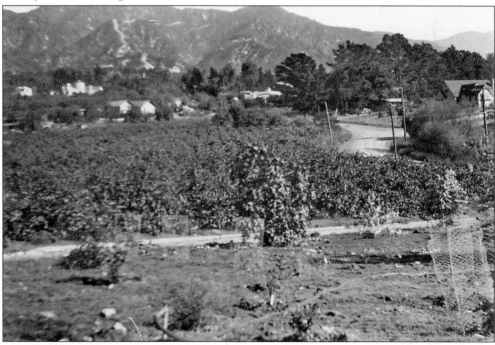

This lovely section of western La Cañada, in the Lone Pine Lane and Tondolea Lane area, was planted in citrus groves and vineyards in the 1920s through the 1940s. Beautiful estates dot the hills. (Courtesy of the MacConnell family.)

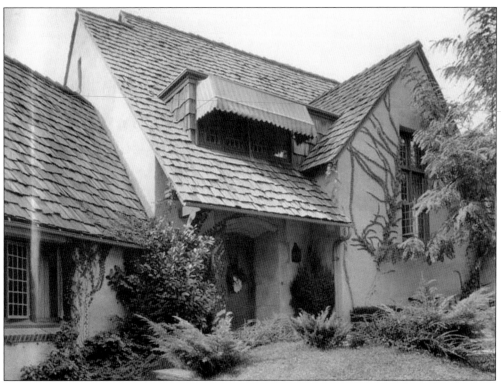

The brother of Sen. Frank Flint, William Flint, lived in this house at 734 Flintridge Avenue. (Courtesy of California State Library Picture Catalog.)

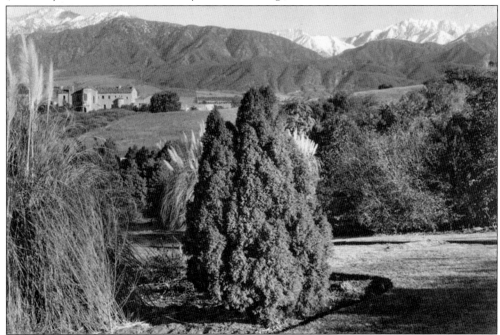

In 1922, this was the view of the snowcapped San Gabriel Mountains from a valley home. (Courtesy of California State Library Picture Catalog.)

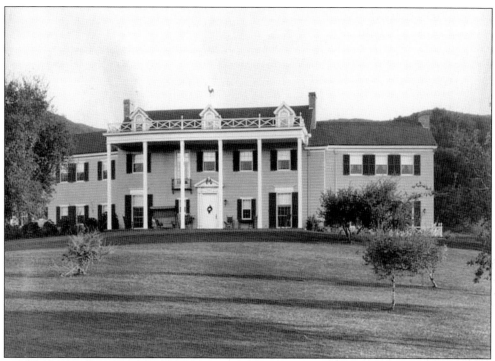

This house, built in 1922, was the home of H. S. McKay, an attorney. (Courtesy of California State Library Picture Catalog.)

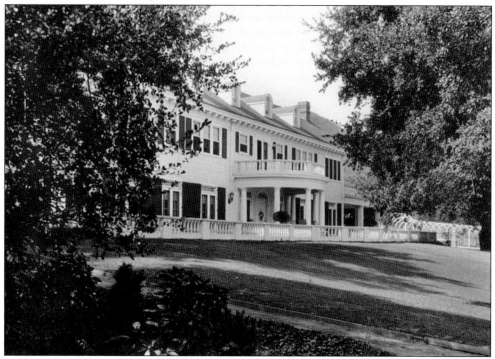

This was the house of Sen. Frank Flint in 1922. Senator Flint developed Flintridge. (Courtesy of California State Library Picture Catalog.)

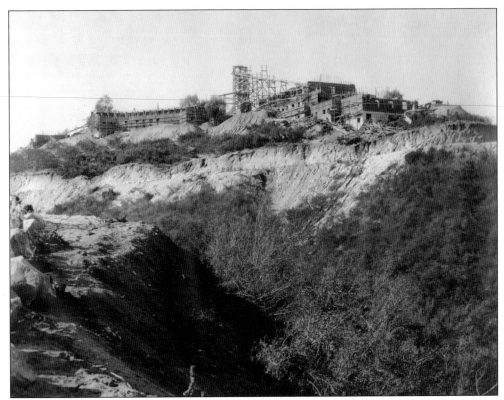

This photograph was taken from across the canyon during the building of the Flintridge Hotel in the late 1920s. (Courtesy of Lanterman Historical Museum Foundation.)

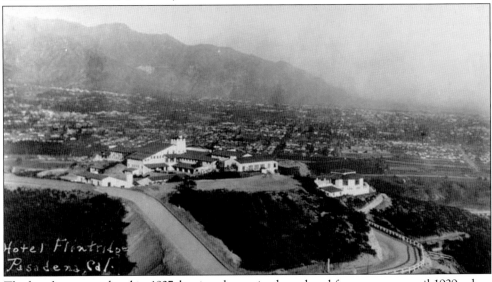

The hotel was completed in 1927, but it only survived as a hotel for two years, until 1929, when financial catastrophe affected all travel and leisure, as well as business. In September 1930, it reopened as the Flintridge Academy for Girls, now known as Sacred Heart Academy, which sits on the crest of the San Rafael Mountains above La Cañada Flintridge. (Courtesy of California State Library Picture Catalog.)

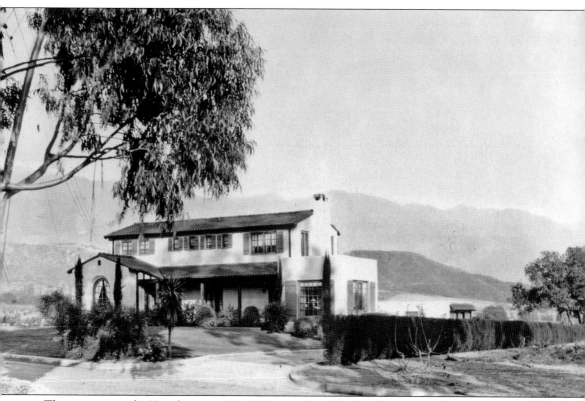

The entrance to the Kirst house on Gould Avenue faced the Eucalyptus trees that were protected in the deed signed by the Kirsts when they bought the property from Will D. Gould in 1920. The Eucalyptus trees still survive on Gould Avenue, but the house did not when the freeway was built. (Courtesy of the Kirst collection.)

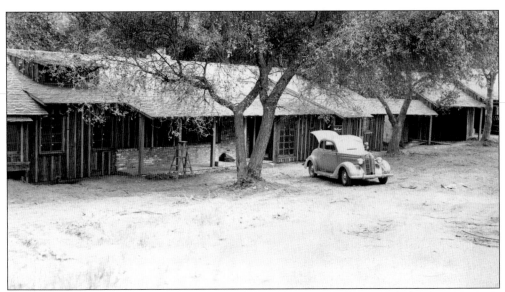

This modern, sprawling, California ranch-style house, characterized by its single-level construction (a design that was felt to be better suited to withstand California earthquakes), was built on Woodleigh Lane by Nelson Hayward Construction Company, before the style became the formula for tract homes in the 1950s. (Courtesy of Glendale Public Library, Special Collections.)

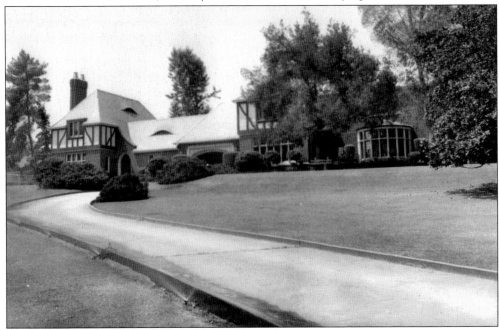

This photograph of English actor Victor McLaglen's house, Fairhaven, was taken in 1959, after the McLaglens sold it. In his backyard, McLaglen kept a zoo, complete with kangaroos. He entertained many Hollywood personalities at this English Tudor revival estate. He was also a motorcycle hobbyist and led a motorcycle club for a more reputable crowd who enjoyed stunt riding as a sport. Lloyd Ungermann, also of La Cañada, rode in this group. This replica of an English manor house still stands today, in all of its majesty, but the acreage has been whittled down through the years. (Courtesy of Glendale Public Library, Special Collections.)

Six

RECREATION
HIKING, CAMPING,
HORSEBACK RIDING, AND GOLF

Oak Grove Park, pictured here c. 1919, was the summer campground for La Cañada. The Arroyo Seco stream usually flowed into a vernal pool, which sometimes stayed full until the end of summer. A dam was built below the pool to protect Pasadena and Los Angeles from the terrible floods that rushed down the mountains through the Arroyo Seco in rainy seasons. When it rained, the pretty stream became a roaring river of mud and debris, hence the building of the dam in 1920. The dam was named Devil's Gate because of the likeness to a devil's head in a rock formation on one of the cliffs at the dam's site. Before Angeles Crest Highway was built, the Arroyo Seco was a popular entrance to the trails, which led to exquisite campgrounds in the Angeles National Forest in the San Gabriel Mountains behind La Cañada and Pasadena. These campgrounds could only be reached on foot or by horse or mule. The trails, which had probably been deer trails at one time, could be found by traveling through the canyons north of the Arroyo. In remembrance of the people who once lived along the Arroyo, the park was renamed Hahamongna Watershed Park in the 1990s. (Courtesy of California State Library Picture Catalog.)

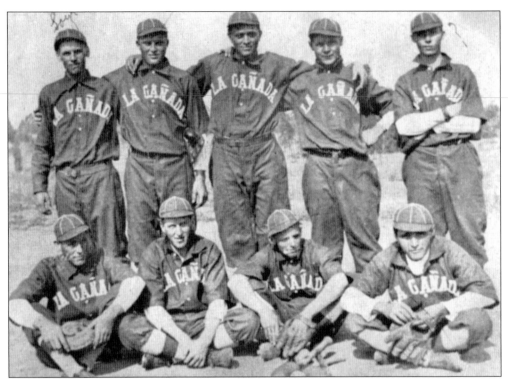

The La Cañada baseball team, pictured here in the late 1910s, from left to right, are (first row) Frank Hansard, Max Green, Harold Gould, and John Bonso; (second row) Lloyd Pate, Al Kirst, Burt Kirst, D. Hood, and unidentified. (Courtesy of the Kirst collection.)

It was difficult to keep the championship golf course at the Flintridge Golf Course green some years. The golf club held many social events for the people of the valley throughout the year, such as the fireworks display on the Fourth of July. This 1922 photograph was taken during one of those dry years. In those days, the golfers were not discouraged by a few dry spots. The golfing days did not last forever though. The club was sold in 1945, and St. Francis High School for boys opened at the facility in 1946. (Courtesy of California State Library Picture Catalog.)

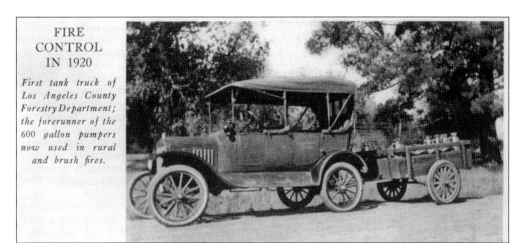

In 1920, the first tank truck of the Los Angeles County Forestry Department carries water in the trailer. (Courtesy of Glendale Public Library, Special Collections.)

Just west of this bridle path was the Gouldmont-Flintridge Riding Academy. St. Bede's Catholic Church was built on this site in the early 1950s. (Courtesy of Glendale Public Library, Special Collections.)

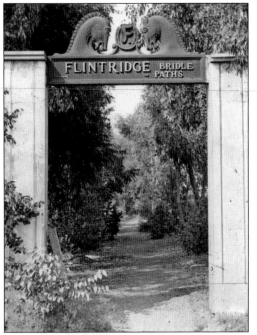

The Gouldmont-Flintridge bridle paths meandered through Flintridge along the Arroyo Seco and up into the edge of Angeles National Forest, circling around Gould Canyon, up to where Pizzo Ranch Road is now. (Courtesy of Glendale Public Library, Special Collections, George Ellison.)

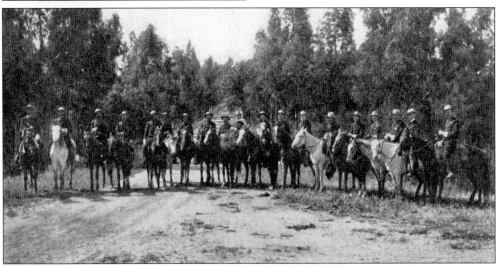

These are some of the forest rangers of the San Gabriel Timberland Reserve, the first forest reserve to be created in California and the second in the United Sates. In 1892, when it was created, it contained 555,520 acres and covered the San Gabriel Mountains from Pacoima Canyon in the west, to the Cajon Pass in the east. Many of the boundaries have changed since that date. From 1892 until 1897, there were no forest administrative officers in charge. After a huge forest fire, which lasted three months in 1896, B. F. Allen was appointed as special agent and supervisor to oversee all of the forest services in California, New Mexico, and Arizona. His headquarters were in Los Angeles. There were 32 forest rangers appointed to California and Arizona in 1898. E. B. Thomas, 10th from the left, was in charge of the western edge of the San Gabriel Reserve (now the Angeles National Forest). Many southland sites, such as Newcombe Ranch, Switzer's, Waterman, Charlton, Hall-Beckley, and Lukens were named after these early rangers. (Courtesy of Glendale Public Library, Special Collections.)

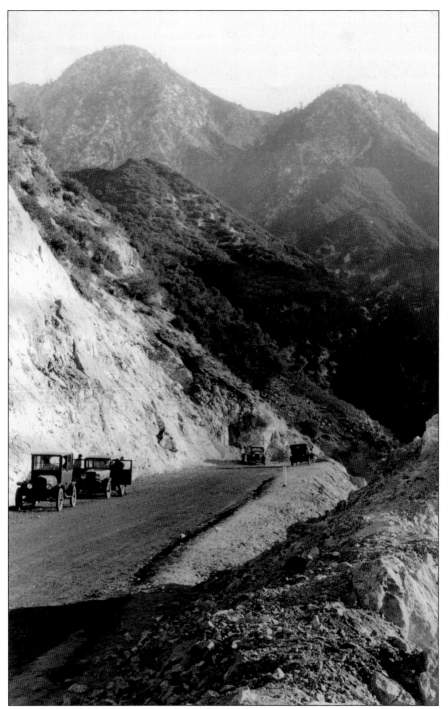

This is the opening of the Angeles Crest Highway. The first engineering work of record (other than the Soledad Grade, which began around Gould Castle) was sponsored by the Automobile Club of Southern California in 1919. After the highway's opening in 1929, access to the forest began to increase as pieces of the highway were gradually added on. (Courtesy of Lanterman Historical Museum Foundation.)

No longer were only the sturdiest hikers and horseback riders camping in the forest behind La Cañada. Opid's, one of the old campgrounds, could now be reached by car. (Courtesy of Glendale Public Library, Special Collections.)

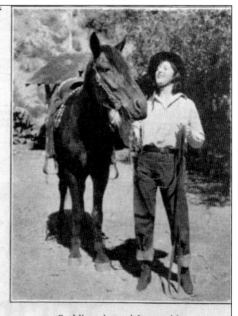
The DeVore family leased five acres from the forest service for Valley Forge Lodge. People would hike or ride a horse or burro to get to the mountain camps before the highway was constructed. The DeVores led pack trains into the mountains to Valley Forge and surrounding sites, from 1913 well in to the 1930s, when Valley Forge was completely flooded by the heavy rains of 1938. Debris from the construction of the Angeles Crest Highway buried most of the cabins. (Courtesy of Glendale Public Library, Special Collections.)

Switzer-land was the destination of many hikers and backpackers—along with Opid's Camp. Before Angeles Crest Highway was built, the only access to Switzer-land was on foot or horseback. After Angeles Crest, it was possible to drive the 10 miles to reach the chapel at Switzer's, which was designed by Arthur Benten, the architect who drew the plans for the Mission Inn in Riverside. (Courtesy of Glendale Public Library, Special Collections.)

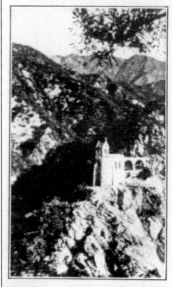

In the 1930s, Joe and John Castellano hiked in the San Gabriel Mountains behind La Cañada before the great fire and flood of 1938 washed out the majority of the cabins and resorts. They would take a trail, either by hiking or by horseback, through the Arroyo Seco to Switzer's camp or Opid's. (Courtesy of the Pizzo family.)

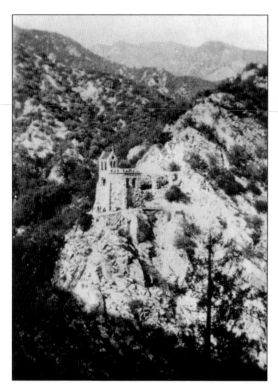

This was the chapel at Switzer's before the 1930s. The story goes that Bob Waterman took a packhorse up the Arroyo Seco with his wife on their honeymoon and found this spot in 1883. Commodore Perry Switzer (his first name was Commodore), a friend of the Watermans, and with the help of their friends, built the camp and chapel at Switzer's Camp. In 1896, a forest fire damaged some of the cabins. After the construction of Angeles Crest Highway, motor tourists were able to travel here and to points beyond. (Courtesy of Glendale Public Library, Special Collections.)

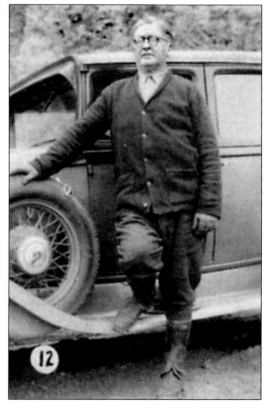

W. B. Albertson, one of the early builders of the Angeles Crest Highway, began working before the first bond amendment of 1919 was approved to build the westerly section from Foothill Boulevard in La Cañada to the Red Box divide. He worked on the highway from 1915 to 1947. (Courtesy of Glendale Public Library, Special Collections.)

R. W. Brown (in front) worked on the highway from 1918 to 1926. The State Division of Highways took care of the surveys for the section from La Cañada to Red Box, whereas, Red Box to Big Pines was surveyed by the U.S. Bureau of Public Records. (Courtesy of Glendale Public Library, Special Collections.)

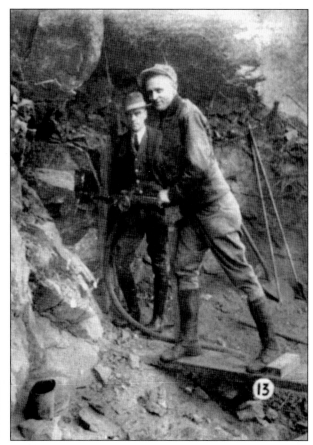

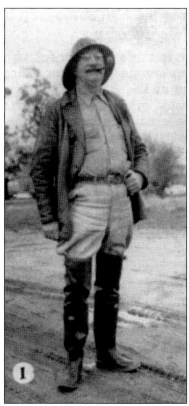

L. A. McCandless began working on the highway in 1928. He oversaw construction of various parts of the highway, sometimes in conjunction with the U.S. Forest Service and workers from the honor camps. (Courtesy of Glendale Public Library, Special Collections.)

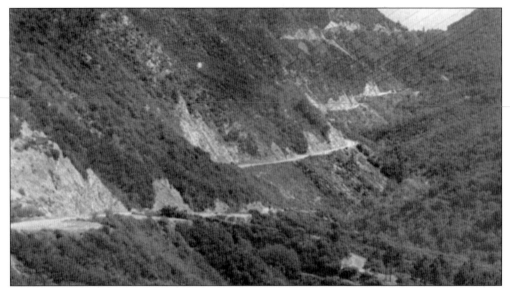

The construction on Angles Crest Highway began in four sections. The first started in La Cañada and extended four miles into the mountain. At that time, two day-labor camps, Camp D and Camp K, were created (1930–1933) as relief work for the homeless, to alleviate the unemployment situation in the Los Angeles vicinity. This work included clearing brush, erosion control, and grading pioneer roads. In 1934, the state highway contracts were able to complete the construction from La Cañada to Red Box. (Courtesy of Glendale Public Library, Special Collections.)

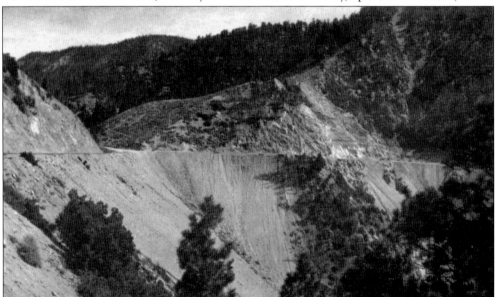

From 1934 to 1956, the next phase of construction on the highway was carried out through eight contracts by the U.S. Bureau of Public Roads, with financing from the national forest highway funds. Simultaneously the State Division of Highways used day-labor work financed from funds budgeted by the California State Department of Corrections. Honor Camps No. 31, No. 35, and No. 37 completed all of the construction between Red Box and Big Pines that was not done by the U.S. Bureau of Public Roads and contracts. (Courtesy of Glendale Public Library, Special Collections.)

Seven

DESCANSO GARDENS
MANCHESTER BODDY'S VISION

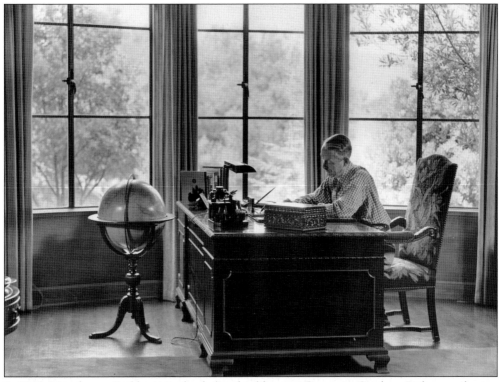

In 1944, Manchester Boddy sits at the desk in his library at Descanso Gardens. Before purchasing and creating Rancho del Descanso, the Boddys lived in Alta Canyada at 5251 Linda Vista Drive. Alta Canada was a very progressive land development with underground utilities in the late 1920s and early 1930s. This community suited Manchester Boddy's vision in modern thinking and technocracy. However, Boddy also admired the self-sufficiency of the utopian groups, such as the "Little Landers," in Tujunga. When he built Descanso, it was his mission to create a self-sufficient piece of land. Between 1920 and 1923, Boddy, who ran his own company locating and ordering books for schools, met Harry Chandler, publisher of the *Los Angeles Times*. Together they began the Times Mirror Book Publishing Company, specializing in Southern California historical and biographical works, textbooks, and lives of movie stars. In 1926, Boddy began the *Daily News*, a tabloid-format expose newspaper of municipal corruption. While living in Alta Canyada, circulation for the *Daily News* had become an economic leader, and Boddy was propounding the "Land Chest" theory, that every family should have a few acres of land on which to be self-supporting. (Courtesy of the Descanso Gardens Archives.)

In 1935, Boddy took out an option to buy 125 acres of oak and chaparral, which was in mortgage by the Bank of America in La Cañada. In 1936, he began planting camellias under the oaks, before the purchase was finalized in 1937. In 1938, the Boddys built the family home. In 1939, Boddy added 40 more acres and named the property Rancho Del Descanso. To make Descanso self-supporting, he began to cultivate flowers and raise livestock and was able to buy the 440-acre Hall-Beckley Canyon, near his old home on Linda Vista. From Hall-Beckley Canyon, he built an underground aqueduct across the valley to the ranch. (Courtesy of the Descanso Gardens Archives.)

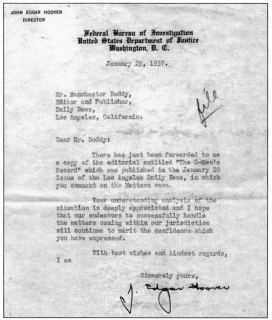

The Boddy Archives at Descanso Gardens include most of Boddy's editorials, photographs, and letters. In addition to the letters from J. Edgar Hoover are very interesting personal letters from Walter Winchell, Sinclair Lewis, Pearl S. Buck, Richard M. Nixon, Louis B. Mayer, Mary Pickford, Earl Warren, and many more writers and political and movie personalities. (Courtesy of the Descanso Gardens Archives.)

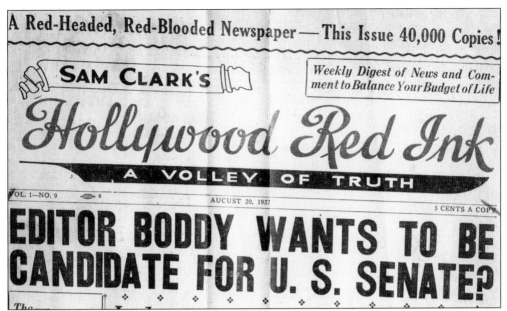

Boddy was very active in politics, as he was very active in everything. But this Hollywood newspaper's headline was either very prophetic, or about 12 years premature. (Courtesy of the Descanso Gardens Archives.)

These were radio personality Irene Rich's rabbit hutches for the Angora rabbits she imported from Harrods Ltd. of London. She kept these hutches at Boddy's Rancho del Descanso in 1938. This area is now the parking lot and main entrance to Descanso Gardens. Other crops and outbuildings are also visible in the area. (Courtesy of the Descanso Gardens Archives.)

From Irene Rich's Angora Rabbit Hutches

In 1938, Irene Rich poses for the newspapers and marketers as she shares a carrot with "Mr. Bing-of-the-Muffs." (Courtesy of the Descanso Gardens Archives.)

This charming short-sleeved salmon-colored evening sweater was made entirely by Miss Rich and her rabbits, and set a new style for Hollywood. Now many stars of Cinemaland, including Joan Crawford, are knitting

Not only did Irene Rich raise rabbits, she also sheared, spun and dyed their fur. This Hollywood effort was in keeping with the self-sufficient spirit of patriotic progressives of the time. Rich is modeling one of the sweaters she knitted with her yarn.

Manchester Boddy, James Stewart, Spencer Tracy, and others discuss a scene in this publicity photograph for Boddy's one and only motion picture, *Malaya*. He wrote the story for this 1949 classic and used the proceeds that he made to build the Lake House at Descanso Gardens. Also in the cast were Gilbert Rowland, John Hodiak, Lionel Barrymore, and Sydney Greenstreet. (Courtesy of the Descanso Gardens Archives.)

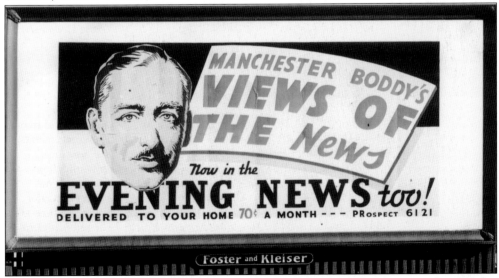

Boddy's editorials were becoming popular and newspaper sales were increasing. In 1939, his progressive newspaper was the only rival to the conservative competition. (Courtesy of the Descanso Gardens Archives.)

Conserve for VICTORY

ISSUED WITH THE COMPLIMENTS OF

DAILY NEWS
CALIFORNIA'S FASTEST GROWING NEWSPAPER

★　★　★　★　★　★　★　★

Conservation was patriotic in 1942, and scrap metal, rags, and old papers were recycled and used for national defense. This brochure included a list of ways that conservation was useful in World War I, stating that peach pits were collected in large stores for use in chemical warfare. Shoes were also dyed in three shades, instead of over 200, during that time, to more efficiently use U.S. manufacturing resources. (Courtesy of the Descanso Gardens Archives.)

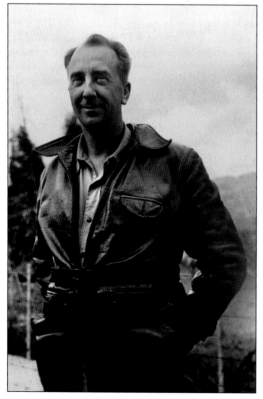

Walter Lammertz, pictured at Descanso Gardens in 1947, was employed by Boddy in 1945 to hybridize specialty plants and develop new varieties. Lammertz hybridized native plants, such a ceanothus, pyracantha, flowering fruit trees, lilacs, and roses. Among the rose varieties that he created at Descanso were Golden Showers, a yellow climbing or pillar rose (1956); Chrysler Imperial, a deep red hybrid tea; and Queen Elizabeth, a deep pink hybrid tea (1954). He created the Charlotte Armstrong hybrid in 1941 before coming to Descanso. In 1945, he was a national gold honor medalist in the American Rose Society and one of the most active rose hybridizers in the United States. He introduced 46 roses, many of which were climbers, pillars, floribundas, and grandifloras. In 1948, he designed the Old Rose Garden, which was a world-class rose history garden at the time. It was totally relandscaped in the 1990s due to soil depletion. Some of the original varieties were not replaceable, however. (Courtesy of the Descanso Gardens Archives.)

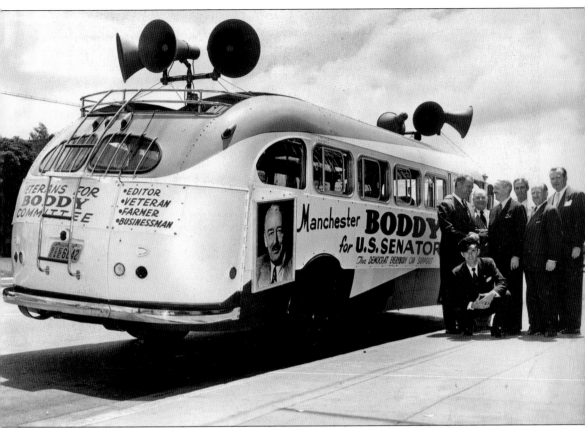

In 1950, Boddy ran for U.S. senator against Helen Gahagan Douglas for the Democratic ticket but lost. Douglas lost to Richard M. Nixon, though, as the political tides were changing. Nixon's campaign referred to Douglas as "The Pink Lady." Government programs began to be associated with socialism and it was feared they would lead to communism. This fear became so entrenched that government programs were drastically cut in the United States, to the extent that U.S. aide was becoming more available to other countries than it was to the U.S. taxpayers. This was the beginning of the end of beautiful public facilities, roads, and programs that could be shared by all. (Courtesy of the Descanso Gardens Archives.)

In 1952, the Boddys had Queen Juliana and Prince Bernhard as guests at Descanso Gardens. Manchester is driving, with Bea seated beside him, and the prince and queen seated in back. This bridge still crosses over the stream at Descanso. (Courtesy of the Descanso Gardens Archives.)

This was the Garden House on the main lawn at Descanso Gardens. Many flower shows were hosted there—but only after the cattle were removed and the lawn grew in. (Courtesy of the Descanso Gardens Archives.)

John Threlkeld, pictured with his secretary Marilyn Zinn, was the first superintendent of Descanso Gardens after Manchester Boddy sold it to Los Angeles County. (Courtesy of the Descanso Gardens Archives.)

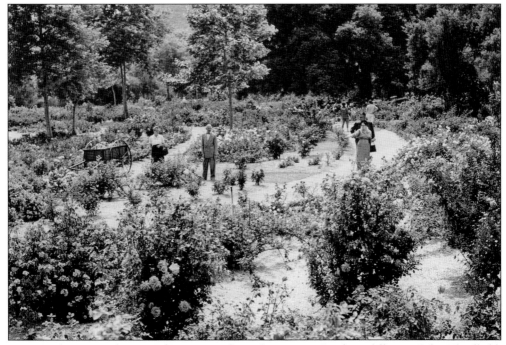

Marc Anthony was the second superintendent of Descanso Gardens, following John Threlkeld. Here he stands in the Old Rose History Garden at Descanso Gardens in 1955. (Courtesy of the Descanso Gardens Archives.)

Theodore Payne designed Descanso Garden's native plant section and called to attention California's native plants. It was time, he believed, for Californians to appreciate and develop the beautiful plants that grew naturally in California, rather than importing plants from other parts of the world, which didn't suit California's climate or soil conditions. Payne studied landscaping and the science of plant culture in England. In 1906, he presented his first wildflower catalog, "The Cause of Natives and their Preservation." In this 1955 photograph, Mr. and Mrs. Payne are signing in at the first Rose Show at Descanso Gardens. (Courtesy of the Descanso Gardens Archives.)

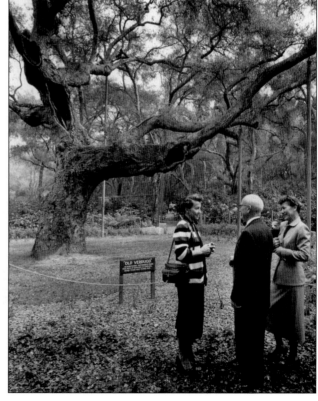

"Old Verdugo" was the oldest tree at Descanso; it had seen the days of the Spanish rancheros. Perhaps its acorns were food for people who lived there much earlier, and its hollows and branches had probably been the home of countless creatures. It was said that "Old Verdugo" died of old age when its remaining trunk was removed in the 1960s. The tree had been hollow for decades, and one story told of the tree's hollow trunk being a hiding place for wine during Prohibition. It is pictured here with its branches on supports in an effort to keep it standing. (Courtesy of the Descanso Gardens Archives.)

In 1956, the camellias were still young at Descanso Gardens. Children loved to come to Descanso and feed the ducks or hike along the trails looking for turtles, lizards, snakes, and frogs. Nature study classes were offered for children, and the horticulture societies presented many colorful flower shows, such as the daffodil, rose, and camellia shows at Descanso Gardens. After Boddy sold the ranch in 1953 to the county to be used as a public garden, it was run by the County of Los Angeles until the 1990s, when the county budget fell into hard times. (Courtesy of the Pizzo family.)

Don Graf, driving the tram here in 1963, was in charge of Descanso Garden's information section. He knew the Boddys personally and still remembers much of the history of Descanso Gardens and La Cañada. He lived as caretaker on the upper floor of the Boddy House with his family and was in charge at the information and tour center from the 1950s until the 1990s, when the Descanso Gardens Guild decided to use the Boddy House for administrative offices. (Courtesy of the Descanso Gardens Archives.)

George Lewis (left) was the last superintendent of Descanso Gardens fully employed by the County of Los Angeles Arboreta. He is standing next to Mike Marshall, grounds supervisor, and Don Graf, information supervisor. Only a few Los Angeles County Arboretum employees remain in 2006. The guild now operates Descanso Gardens. (Courtesy of the Descanso Gardens Archives.)

Pictured here in the 1980s, some of the remaining L.A. County crew are Don Graf, Darryl Koons, Paul McBride, and Lew Soibelman (second from left) was one of Descanso Gardens Guild's first hired employees. The county was relinquishing control of many of its public facilities and services, due to financial hardship, and private groups began to run them as businesses and nonprofit organizations. Many Descanso visitors will remember the tram tours and information services provided by Don Graf and Paul McBride. Lew Soibelman was instrumental in obtaining the Descanso Railroad and its engines. Darryl Koons was the senior mechanic in charge. (Courtesy of the Descanso Gardens Archives.)

Eight

MAPS AND AERIAL VIEWS

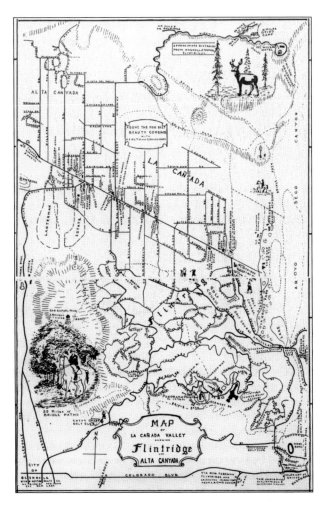

This 1930s map of La Cañada Valley includes Flintridge and Alta Canyada, which were land developments seeking more autonomy at that time. (Courtesy of Glendale Public Library, Special Collections.)

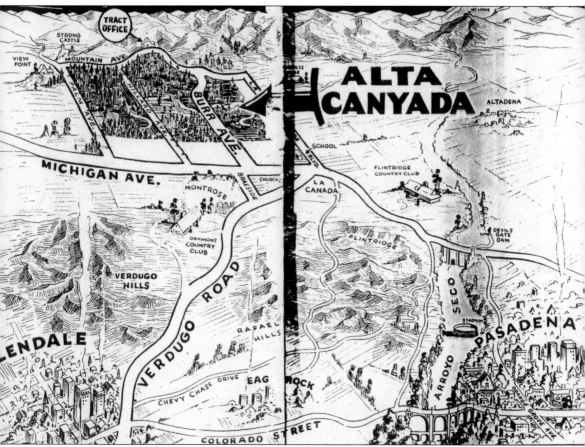

In this Alta Canyada land development map (definitely not to scale), Strong's Castle is pictured at the top of Palm Avenue. Foothill Boulevard was still Michigan Avenue. AltaCayada Drive was named Burr Avenue and also, at one time, had the name Ohio Avenue, as many of the streets that ran from north to south were named for states. (Courtesy of Glendale Public Library, Special Collections.)

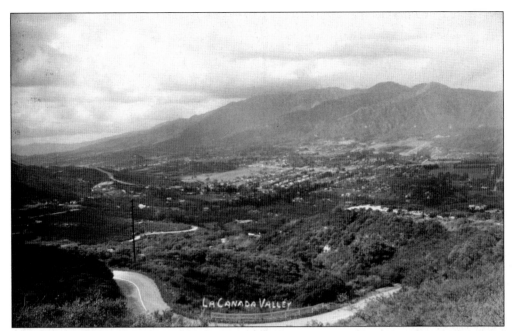

This early 1900s aerial postcard shows a view from a Flintridge hillside, just west of Devil's Gate Dam, looking toward La Crescenta. (Courtesy of Glendale Public Library, Special Collections.)

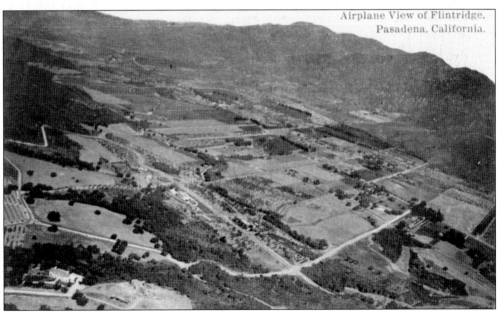

This aerial view postcard of Flintridge in Pasadena, California, looks a lot like La Cañada. The silhouette of the San Gabriel Mountains can be seen against the sky at the top of the photograph. Michigan Avenue can be seen crossing though the middle of the valley, diagonally, toward Tujunga. Some Flintridge residents would have rather joined with Pasadena than with La Cañada. Such was the land-development struggle in the early 1900s. This image is from a collection of some of the early tract developments of Frank Flint around 1916. (Courtesy of Glendale Public Library, Special Collections.)

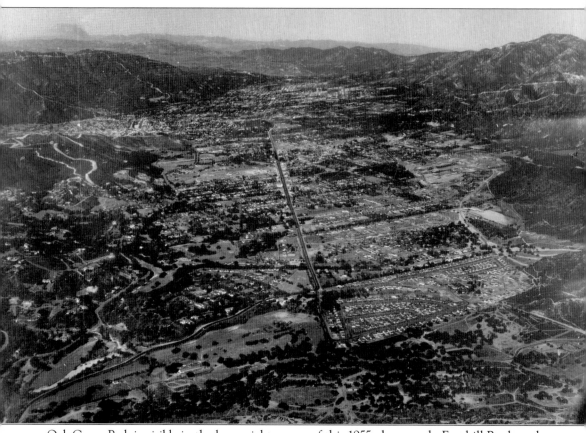

Oak Grove Park is visible in the lower right corner of this 1955 photograph. Foothill Boulevard cuts down the center vertically. (Courtesy of Glendale Public Library, Special Collections.)

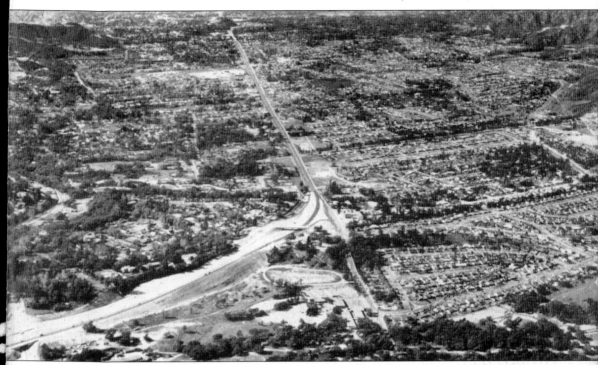

The interim Foothill Freeway, which connected Pasadena with La Cañada, is pictured here in 1955. Below the freeway is where Flintridge Golf Course had once been. The Kirst development can be seen in the lower right corner to the right of the old golf course. The country club buildings became St. Francis High School. (Courtesy of Glendale Public Library, Special Collections.)

ACROSS AMERICA, PEOPLE ARE DISCOVERING SOMETHING WONDERFUL. *THEIR HERITAGE.*

Arcadia Publishing is the leading local history publisher in the United States. With more than 3,000 titles in print and hundreds of new titles released every year, Arcadia has extensive specialized experience chronicling the history of communities and celebrating America's hidden stories, bringing to life the people, places, and events from the past. To discover the history of other communities across the nation, please visit:

www.arcadiapublishing.com

Customized search tools allow you to find regional history books about the town where you grew up, the cities where your friends and family live, the town where your parents met, or even that retirement spot you've been dreaming about.